Early
WILDLIFE
Photographers

Early WILDLIFE Photographers

by C.A.W. Guggisberg

Foreword by
Eric Hosking
Hon FRPS FIIP

TAPLINGER PUBLISHING COMPANY
New York

By the same author

Crocodiles
Wild Cats of the World

First published in the United States in 1977 by
TAPLINGER PUBLISHING CO., INC.
New York, New York

Library of Congress Catalog Card Number: 76–54404
ISBN 0–8008–2352–4

Contents

Foreword
By Eric Hosking, Hon FRPS, FIIP

Today when we look at some of the spectacular natural history films shown on television in the *World About Us* or *Survival* British television programmes, or we see the photographs that illustrate the mass of books published about animals, or even the pictures reproduced in magazines, do any of us spare a thought as to how it all began?

At the turn of the century the photographic safari meant going on a full-blooded expedition walking over rough, sometimes unexplored ground, with a retinue of porters—probably fifty or more natives manhandling enormous brass-bound cameras, heavy lenses, plate-holders, sensitised glass plates, weighty tripods, portable darkroom and developing chemicals in large glass containers, quite apart from tents, food for yourself and your retainers, guns to keep you supplied with fresh meat, cooking pots, clothes sufficient for a year or more, and a mountain of other impedimenta weighing several tons. Today we go on safari in a comfortable mini-bus, carrying modern miniature cameras and light-weight telephoto lenses so that it is difficult for us to even visualise the pioneers with such bulky, heavy equipment. To give some idea of the revolution in photography since those early days, we now carry half a dozen 35mm films in a pocket—enough to take well over 200 photographs—and they weigh less than a single glass negative in its wooden plate-holder which the early natural history photographer had to carry.

Charles Guggisberg, a wildlife photographer himself, has done a great deal of research into the history of the early workers and brought to light absorbing information about the methods they used, not only to obtain photographs of birds in Great Britain but also the great mammals of the world. He writes of men with utter determination and dedication of spirit who overcame the bitter disappointments and frustrations of apparatus failure at critical moments, who often had to work with a gun-bearer by their side, and he reveals their enthusiasm and excitement when success did come.

This is a fascinating book and I have thoroughly enjoyed reading it.

Introduction

Where the northern slopes of mighty Kilimanjaro merge into a dry, hill-studded plain, you find one of East Africa's most famous game sanctuaries, long known as Amboseli Reserve and now at least partly transformed into a national park. A series of swamps, formed by water emerging from underneath Kilimanjaro's lava fields, make the area highly attractive to wildlife. I have often visited this wonderful reserve in the course of the last thirty years, taking thousands of photographs of animals and birds within its boundaries. On every one of these safaris there have been occasions when my mind flew back through time and space to a certain festive occasion early in the twenties when, under the Christmas tree, I discovered a book entitled *With Flashlight and Rifle*. The bulky volume contained a thrilling account of photographing African wildlife at the turn of the century, mainly around what the author, C. G. Schillings, called the Njiri Swamps—the marshes and pools which are nowadays part of the Amboseli Reserve.

A short time before that memorable Christmas I had read Stanley's *In Darkest Africa* and decided to become an African explorer. Plodding through all the books I could lay my hands on, I soon realised that Africa was not all that 'dark' any more. The sources of the Nile had been discovered long ago and there were, in fact, no major geographical problems left to be solved. My readings made we aware, however, that the African plains were the most wonderful hunting grounds left on earth, literally swarming with animals of many kinds. As animals had been a main interest of mine ever since I was able to crawl after snails and ants in the garden, I began to wonder—much to my parents' horror—whether elephant hunting might not be an occupation to suit my tastes. The exploits so vividly described by Schillings now opened up entirely new vistas. Stalking animals with a camera seemed to be even more exciting than hunting with a rifle.

I cast about for more books on nature photography and almost immediately got acquainted with the work of the Keartons, of A. Radclyffe Dugmore, Kermit Roosevelt, A. Berger and Bengt Berg. When eventually—and quite inevitably—I became a zoologist, I naturally took to recording my observations by means of a camera. Travelling was not as easy during the thirties as it is now, and I had to restrict my activities to Europe, particularly to the Alps, with an

occasional visit to places like the bird islands of Pembroke-
shire or to the marshes of the Danube delta. It was only
after World War II that I found my way to Africa, to the
happy hunting grounds of Schillings, Dugmore and Cherry
Kearton.

During the last two decades, travel has become very easy
indeed, and so has wildlife photography. Schillings would be
utterly amazed if he could see the tourists circling the Njiri
Swamps by the busload, armed with photographic equipment
he could not have visualised in his wildest dreams, and
casually taking close-ups of the animals he spent endless
hours stalking on foot or trying to catch with his flashlight
cameras when they came to the water at night. Where
Schillings, Dugmore and Kearton had to work hard for
weeks and months to obtain a few reasonably good black-
and-white exposures, the modern tourist returns from a
drive of three to four hours with a wealth of splendid colour
slides or with hundreds of feet of excellent cine film. Snap-
ping lions, cheetahs, elephants, rhinos and giraffes has
become matter of fact, an integral part of a well-run safari
holiday.

The tourists visiting African game reserves have not the
slightest conception of the trials and tribulations experienced
by the wildlife photographers of three-quarters of a century
ago, and this even goes for the very few who may vaguely
have heard of the Keartons or of Schillings. They cannot be
blamed, for the books written by the pioneers have long
been out of print, and the excellent manuals initiating you
into the ways and means of modern wildlife photography
are not concerned with the origins and the evolution of this
fascinating pursuit. They do not, for instance, tell you who
was the first enthusiast to carry a camera into Africa for
the explicit purpose of taking pictures of game animals, and
it comes as a surprise to learn that the first efforts in that
direction took place during the early 1860s. Why, then, did
wildlife photography not come into its own until the 1890s?
Was its sudden upsurge due to improved cameras and emul-
sions, or rather to a breakthrough in photo reproduction?
When wildlife photography became popular, it did so with
such speed and on such a large scale—at least in Britain—
that a Zoological Photographic Club came into existence as
early as 1899.

Who was the first bird photographer to use as a hide a
plain, uncamouflaged tent instead of an artificial rock or
tree trunk? Who made the first photographic study of the
flamingo's breeding habits, proving once and for all that
this long-legged bird does not straddle its nest as had been
assumed for a long time? Who first pointed a camera at a
gorilla in its native habitat? At an orang utan, an okapi, a
whale-headed stork? Who took the first photographs of
those rapidly dwindling species, the Sumatran and Javan

rhinoceroses? What use was made of wildlife photography in the cause of conservation?

To answer these questions and others was one reason for my writing this book. There has, however, been another, perhaps even more important one: I sincerely hope that in reading about the difficulties faced by the pioneer photographers, by looking at the cameras they used and the snapshots they produced, you will come to respect those men—and women—as deeply as I have always respected them. Their names and their achievements deserve to be remembered.

Assembling a representative collection of photographs illustrating the work of the pioneer wildlife photographers has been a very laborious business, shared about equally by author and publisher. A quite amazing amount of original material finally came to light, but there were also many failures, many unanswered letters, many apparently promising lines of research which turned into blind alleys. It has been necessary to photograph certain pictures out of books, and all illustrations obtained in this way have been credited accordingly.

The early wildlife photographers were mainly interested in birds and mammals. I have therefore said little about photographing insects and other small fry, and nothing about underwater photography. A full book could, of course, be devoted to the history of each of these two branches of nature photography.

1 The Beginnings

A picture, it has been said, is worth a thousand words; a
sweeping statement, no doubt, but when it comes to fami-
liarising yourself with the almost endless diversity of the
animal world, there may well be something in it. The most
excellent picture is, of course, only second-best to the study
of a live specimen, but what, for instance, could you
visualise from Dr Johnson's description of a giraffe: 'an
Abyssinian animal taller than an elephant but not so thick'
if you had never seen one, nor glanced at even a mediocre
pictorial representation of the animal in question?

Conrad Gesner, the 'father of modern natural history',
fully appreciated the value of illustrations and saw to it that
his monumental work contained woodcuts of every creature
mentioned in the text. Some of these, obviously done from
life, were amazingly good, but where the artist had nothing
to work from except a badly stuffed specimen or a highly
inadequate description, the result left much to be desired.
The great Albrecht Dürer, who portrayed the hare, the stag
beetle and other creatures with a mastery that cannot be
surpassed, came up with something of a caricature when he
tried to draw, probably from a rough sketch sent to him,
the Indian rhinoceros that had reached the court of King
Manoel of Portugal in 1513. This has remained true for a
long time, and we cannot help smiling at some of the illus-
trations appearing in books published as recently as the
middle of the last century. By that time, however, great
progress had already been made in developing an invention
which, in due course, was to provide us with wonderfully
accurate portraits of animals.

This is not the place for a detailed history of photography.
Let us simply recapitulate some of its more important land-
marks. The idea of 'seizing the light' as Daguerre put it, goes
back a long time, and considerable use was made of the
camera obscura—a box with a lens at one end and a glass
screen at the other—by eighteenth-century artists. Unsuc-
cessful attempts to make the projected picture permanent
by means of silver nitrate took place before 1800. The very
first photograph was taken by Joseph Nicéphore Niepce in
1826 on a metal plate coated with bitumen. In 1839, Louis
Jacques Mande Daguerre, working on similar lines as
Niepce, invented the Daguerreotype process based on the
mercury vapour development of silver iodine and bromide
supported on a copper plate, the resulting amalgam being

11

fixed with cyanide or hypo. Before he could publish details of his discovery, Henry Fox Talbot read a paper to the Royal Society, describing the Calotype or Talbotype process, in which paper coated with silver iodine was used. While not giving as clear a picture as the Daguerreotype process, it had the advantage of permitting more than one copy to be made. At first it looked as if Daguerre would win the day, but Fox Talbot kept working on his invention, improving the definition and shortening the exposure. Finally it was the Daguerreotype process which had to give way to the more practical paper negatives.

In 1851, Frederick Scott Archer of London invented the glass plate covered with emulsion. It had to be dipped into a bath of silver nitrate, inserted into a holder and placed in the camera for exposure while still wet. This did not cause too much inconvenience as far as studio work was concerned, but what about its outdoor use? Ingenious photographers designed portable darkrooms which could be erected as tents or placed on waggons, and wet plates were soon being prepared for exposure not only high up in the Alps and among the foothills of the Himalayas, but also on the battlefields of the Crimean and American Civil Wars.

In 1858, getting ready to explore the Zambezi and its tributaries, David Livingstone decided to include a camera among his scientific equipment. Photography fell mainly to Dr John Kirk who had joined the expedition as medical officer and naturalist, and from his diary we learn that he took pictures both on 'waxed paper' and on an early type of dry plate, 'the collodion process of Mr Hill Norris'. After being sensitized in England, these plates were transported in slides and Kirk was delighted to find their properties very little diminished even after four years in the Tropics. He photographed landscapes and botanical subjects, but apparently never tried his hand at taking pictures of wild animals. Serving under such an exacting taskmaster as Livingstone may not have left him time enough for experiments in that direction.

First attempts at photographing African wildlife were, however, made before Livingstone and Kirk left the Zambezi region. Starting on an expedition from Walfish Bay to the Victoria Falls, the explorer and elephant hunter James Chapman took along two cameras with the declared intention of getting exposures of the teeming herds of zebra and wildebeest, of rhino and particularly of elephants. He was to experience one sad disappointment after the other. Owing to lack of time and bad weather he could not get his cameras ashore on Ichabod Island, where he might have had a good chance of exposing some plates of the 'incredible multitude of birds'. One camera was later blown down and broken by a gust of wind, the other fell apart due to the heat. Nothing daunted, Chapman built a new camera out of

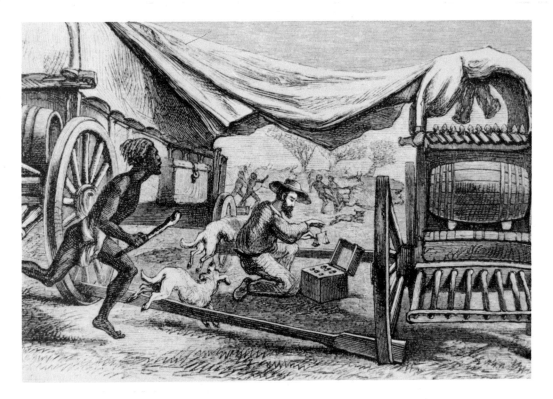

James Chapman: Photography under difficulties: the photographer mixing chemicals amidst the hubbub of his camp. From Chapman, *Travels in the Interior of Africa*

the two damaged ones. He suffered constant losses of irreplaceable chemicals through breakage. Once he managed to set up the camera within reasonable range of a large assembly of game, but one of his men turned up at the wrong moment, and the herds scattered. Chapman had to be satisfied with pictures of some of the beasts that fell to his gun. As far as live animals were concerned, the honours went entirely to his companion, the artist Thomas Baines, who produced many spirited sketches of mammals and birds. At the end of the expedition, Chapman nevertheless had about two hundred 'tolerable photographs'. Among them were some showing that strange desert plant known as *Welwitschia mirabilis*.

A German explorer, Professor G. Fritsch, carried a camera and dry plates into the interior of South Africa in 1863, mainly for anthropological studies, but he also photographed some animals shot by his companions. By that time, quite a few cameras had been pointed at domestic and zoo animals in various parts of the world. An anonymous camera artist photographed His Excellency the Viceroy of India's elephants. A Frenchman, Léon Cremière, produced an album of dog studies in 1865. Using an exposure time of eleven seconds, a photographer named Haes took portraits of lions and other animals in the London Zoo, but failed to obtain a single clear photograph of the continuously

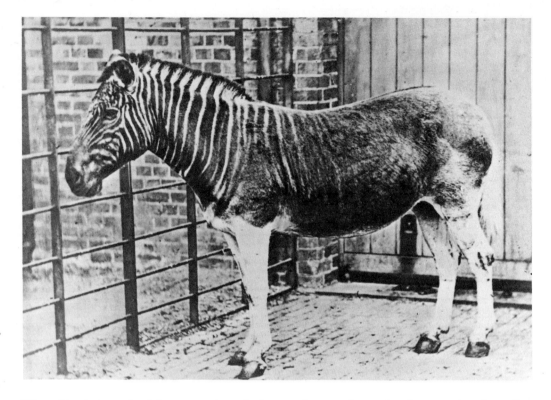

When this photograph of the London Zoo's last quagga was taken the species had already ceased to exist in a wild state (*British Museum of Natural History*)

moving elephants. Among the early photographs of captive animals, one of the most valuable is of the London Zoo's last quagga; when it posed for its picture at the beginning of the 1870s, the species had already become extinct in its native habitat. What would we give for photographs of the bluebuck, of Steller's sea cow, of the aurochs, the dodo!

A picture of a long-eared owl, said to be from a photograph, was published in 1868 in A. W. M. C. Kennedy's book on the birds of Buckinghamshire and Berkshire, but we do not know by whom and under what circumstances it was taken. It may well have been of a stuffed specimen. Most of these early efforts have, of course, been lost long ago, though some could still be hidden in boxes and albums tucked away in cupboards, storerooms or attics. One of the oldest surviving photographs of a 'wild' bird was found during the nineteen-thirties; it is of a stork perched on its nest, taken at Strassburg in May 1870 by Charles A. Hewins of Boston.

For her 1872 to 1876 world cruise which was to put the new science of oceanography on a solid basis, *HMS Challenger* was equipped with a light- and dark-room for photographic work. The technical side of this was taken care of by C. Newbold, a corporal of the Royal Engineers and a very skilful photographer. Among the negatives brought back by the *Challenger* expedition were pictures of

14

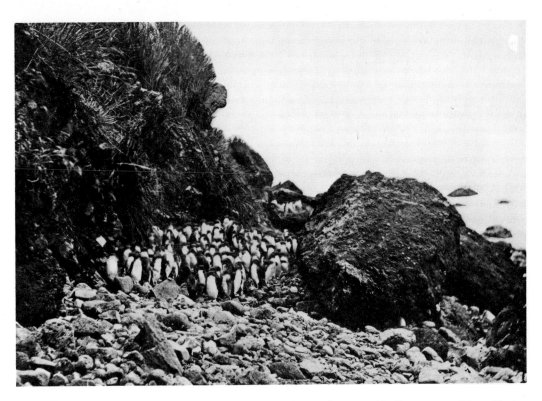

penguin rookeries and of breeding albatrosses. These photographs have been preserved, but if you look for them in publications prepared shortly after the expedition's return, you will find them printed in the form of wood engravings. Half-tone reproduction not yet having been invented, photographs to be used as illustrations in books or periodicals had to be handed to craftsmen who copied them on wood and translated their range of half-tones into delicately engraved lines. What you finally saw was not the actual photograph, but what the engraver had been able to make of it. A method less often resorted to was the mounting of original photographic prints on blank book pages. An early natural history effort of this type was H. G. Vennor's *Our Birds of Prey, or the Eagles, Hawks and Owls of Canada*, published in Montreal in 1876, with thirty mounted photographs of stuffed birds taken by William Notman, famous for his studio portrayals of scenes of Canadian life.

With faster camera shutters, improved lenses and more sensitive plates, exposures short enough to 'stop' a person or an animal moving at a fairly rapid pace became possible. An ex-Governor of California decided to resort to this method in order to solve a dispute that had arisen over the question: 'Is there a certain moment in which all four feet of a galloping horse are off the ground?' He approached Eadweard James Muybridge, an Englishman who had just

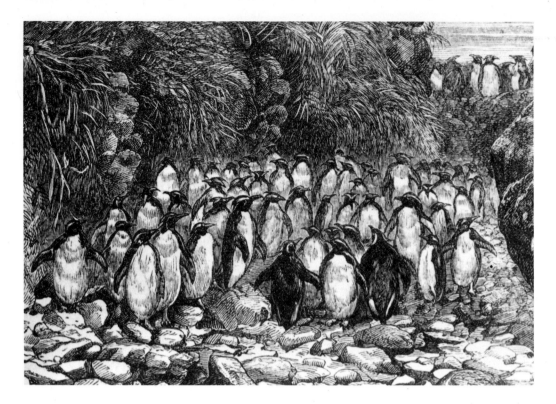

Challenger expedition: Rock-
hopper penguins—a wood
engraving based on the
photograph taken on
Inaccessible Island

taken a camera through the Yosemite Valley, and commis-
sioned him to produce a series of instantaneous photographs
illustrating the exact sequence of movements in a horse at
full gallop. That was in 1872 and several years were to pass
before Muybridge could obtain satisfactory results. He took
his first photographs of a galloping horse in 1877, and in
1878 he set up twelve cameras in a line and had them
released at 1/1000 of a second by a horse breaking strings
as it galloped past. Muybridge was so fascinated by the out-
come that he applied similar methods of study to whatever
animals he found available. When, in 1887, he brought out
his book *Animal Locomotion* which has been invaluable to
artists and taxidermists ever since, he had a collection of
about 100,000 photographs to choose from. Together with
John D. Isaacs, Muybridge invented the Zoopraxiscope, a
revolving disk from which series of photographs could be
projected in motion, and he can therefore be considered as
one of the fathers of cinematography.

Electricity may first have been used in animal photo-
graphy in 1883 by Bernhard Johannes of Partenkirchen, who
placed a camera near a well-used game track and positioned
himself at the end of a long wire, watching with field glasses
and releasing the shutter when an animal passed close to
the lens.

After Muybridge had 'stopped' fast-moving animals at

16

1/1000 of a second, there was no reason for not attempting to photograph birds in flight. This was successfully done in 1888 by Benjamin Wyles of Southport in England with a Derwent camera and dry plates which had come into general use during the sixties and seventies. His studies of gulls at Southport Pier earned him the Silver Medal of the Cornwall Royal Polytechnic Society's Falmouth Photographic Exhibition. Wyles, a chemist who had become a professional photographer, also took some remarkably good pictures of guillemots and kittiwakes at the Farne Islands off England's north-east coast and of gulls at the now defunct Pilling Moss gullery. They were published in the *Strand Magazine*

Eadweard James Muybridge: Tiger studies from *Animal Locomotion*

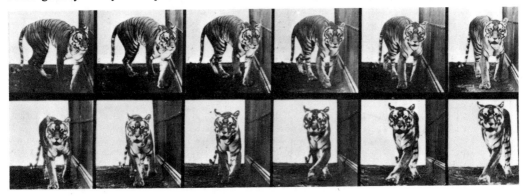

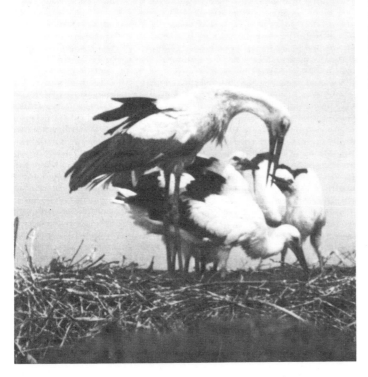

Ottomar Anschütz: White storks, being very tame and nesting in towns and villages, must have been photographed by many early camera enthusiasts. This picture of an adult stork feeding its young was taken in 1884 (*Collection Werner Kourist, Bonn-Bad Godesberg*)

17

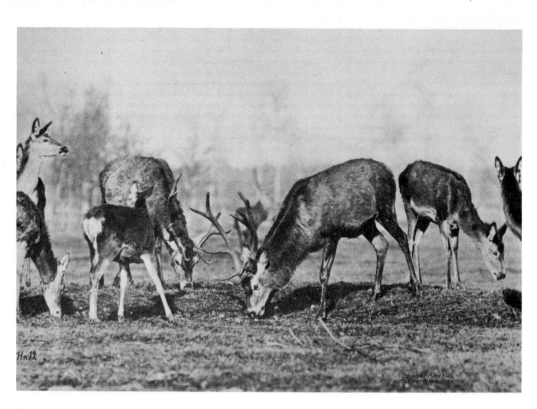

Ottomar Anschütz: The red deer of parks and hunting preserves were the first game animals to be 'stalked' by photographers. This picture was taken at a feeding place in 1889; a photograph of the same herd appeared in the first German natural history book entirely illustrated with photographs in 1897 (*Collection Werner Kourist, Bonn-Bad Godesberg*)

Vol 4, 1892, to illustrate an article of his entitled 'The Camera amongst the Seabirds'.

R. B. Lodge was another professional photographer who took up bird photography at a very early date. Oliver G. Pike, who himself attained great fame in this field, wrote of him: 'I know that Lodge was photographing birds in 1891 and probably in 1890 by the following: I was educated at Enfield Grammar School. Lodge had a portrait photographer's shop about one hundred yards from the school, one window was given up to portraits, the other to photographs of birds. After my school hours, I often went to Lodge's shop to gaze at his photographs, for feeling keenly interested in birds and photography myself, his work fascinated me. I left the school in 1893 at the age of sixteen and I was a frequent visitor to Lodge's shop for at least the two previous years, so he was probably doing his work from 1890.'

It gave young Pike a great thrill when Lodge allowed him to accompany him on his photographic trips into the surrounding countryside. Together they experimented with automatic releases which enabled birds to make exposures of themselves when they returned to their nests. In the spring of 1895, Pike was able to share Lodge's delight when a lapwing released the camera shutter by touching a tripwire placed over the eggs. In 1901, Lodge designed a really

18

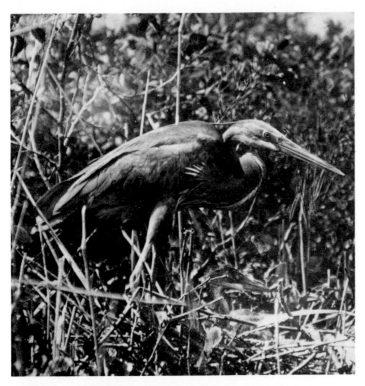

R. B. Lodge: Purple heron at nest (*British Trust for Ornithology*)

R. B. Lodge: Little bittern (*British Trust for Ornithology*)

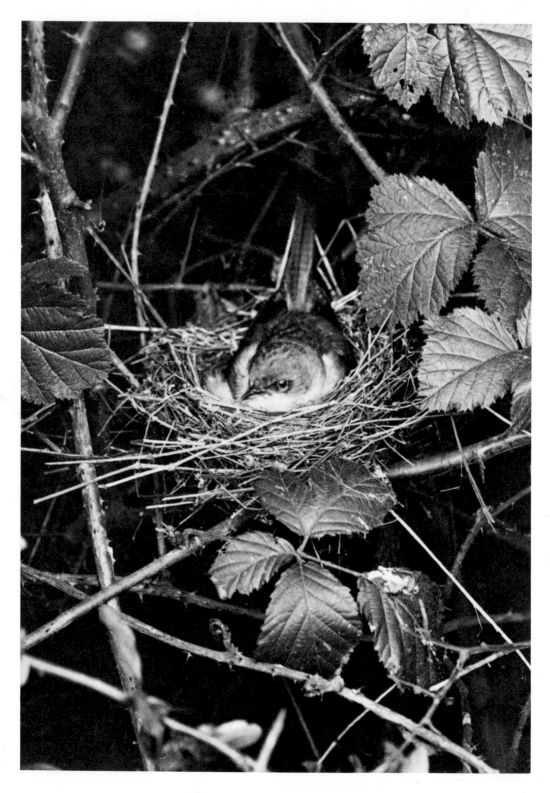

reliable electric shutter which was activated by the pressure of a bird's foot. He also made full use of the telephoto lens invented by Dallmeyer. A good idea of the sheer bulk of Lodge's early equipment has been given by his artist brother, George Lodge, who described to Eric Hosking how the two of them used to push a 12 x 10in plate camera about on a wheelbarrow. In 1895, Lodge was awarded the Royal Photographic Society's first medal for natural history work.

Lodge took his camera to Holland, Denmark, Spain and the Balkan countries in search of spoonbills, storks, egrets, glossy ibis, buff-backed and night herons, pelicans and griffon vultures. From 1904 onward he published several books, all of them well written and most interestingly illustrated. By that time, of course, book illustration had undergone a fundamental change thanks to the invention of half-tone reproduction in which the graduated tones of the original photographic print were translated, not into lines, but into dots of uniform tone, though varying in size. Photographs could now be reproduced directly, without the intermediary of a wood engraver, and this gave a tremendous boost to their use in books, magazines and newspapers.

The first natural history book to be entirely illustrated with authentic wildlife photographs was *British Birds' Nests* by Richard and Cherry Kearton, published in 1895 and followed in quick succession by the same authors' *Nature and the Camera* (1897), *Our Rarer British Breeding Birds* (1899) and *Our Bird Friends* (1900). The Kearton brothers grew up at Thwaites in the upper part of the Swales Valley of Yorkshire. Their interest in the ways of nature was awakened at an early age by a bird loving grandfather and an amateur-naturalist father who took his sons on rambles through the wild mountain country inhabited by curlews, golden plovers and merlins. 'It was not long', wrote Richard, the elder, 'before I knew where to find the nest of every species breeding in our neighbourhood and to distinguish the cry of any feathered friend almost as soon as it was uttered.'

Richard Kearton broke his hip as a result of a fall off a wall and was confined to the house for many weary months. The accident left him with a permanent limp but did not detract him from his nature studies, nor does it seem to have handicapped him unduly in the strenuous activities he indulged in all through his life. If occasionally he did have to make a virtue out of necessity, this only taught him that the watcher sitting quietly in a secluded spot often sees and learns more than the man who rushes all over the place. He was an excellent observer and careful note-taker, and the various experiments he devised while watching birds at their nests quite definitely make him a pioneer ethologist.

It must have been hard for Richard Kearton to leave Yorkshire, but he eventually went to London and entered

Richard and Cherry Kearton: Lesser whitethroat on nest (John Kearton)

the firm of Cassell's, the publishers. Four years later, after the death of their father, Cherry joined him in Cassell's advertising department. The younger Kearton became interested in photography and on an outing to Enfield in 1892 he took a picture of a song thrush on its nest which came out so well that Richard suggested the production of a book on British birds' nests, with himself writing the text and Cherry taking on most of the photographic work. Thus originated the partnership which has done so much to establish nature photography, not only as one of the most fascinating and enjoyable hobbies, but also as a help in behaviour studies and, last but not least, as a means of arousing an unprecedented interest in wildlife.

In order to get close-ups of breeding birds, the Keartons experimented with various types of camouflage for both camera and photographer. They not only designed artificial

Richard and Cherry Kearton: An early hide in the form of an artificial tree trunk, designed and used by the brothers in 1898 (*Cherry Kearton*)

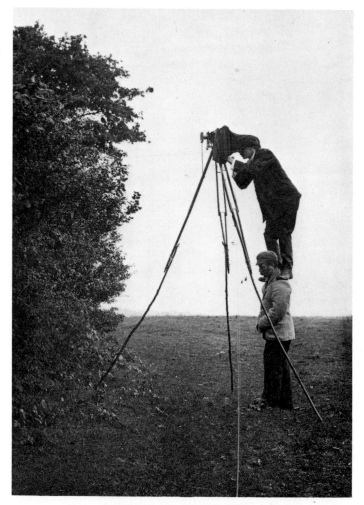

Richard and Cherry Kearton: The Kearton brothers at work with Cherry standing on Richard's shoulders to photograph a nest high up in a hedge (*Cherry Kearton*)

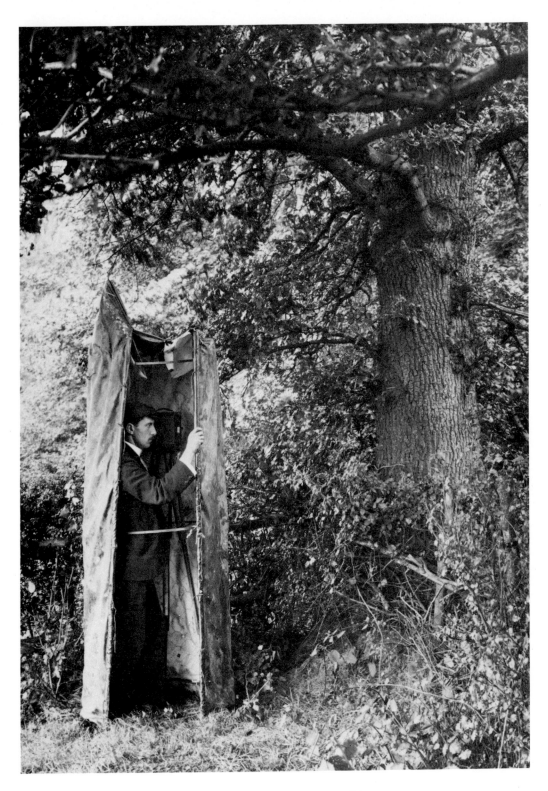

rocks and tree-stumps, but also used a wooden mask, a dummy bullock and a stuffed sheep. Sometimes they built a small stone shelter close to a nest, and quite often they used a little tent carefully covered with grass sods, heather or whatever other material appeared most suitable to make it merge with its surroundings. They designed a gun-camera for 'shooting' flying birds. Dangling from a rope, Cherry photographed seabirds on the cliffs of St Kilda, Ailsa Craig and Bass Rock. At other times, one or the other of the Kearton brothers stood for hours up to his chest in water waiting for some marsh bird to return to its nest.

As more and more books—monuments of extraordinary patience and tenacity as Cecil Beaton has called them—reached an eager public, they were found to contain not only pictures of birds, but also of small mammals, lizards and snakes, of caterpillars, butterflies and moths. The wide range of the Keartons' interests can be judged from *Wild Nature's Ways* (1903), *Keartons' Nature Pictures* (1910) and from their charmingly illustrated edition of Gilbert White's *Natural History of Selborne,* first published in 1903 and reprinted in 1924. When this reprint became available, Cherry Kearton had long since gone on to photograph wildlife right across the world, as will be told later.

Oliver G. Pike, who accompanied Lodge on some of his

Richard and Cherry Kearton: The famous dummy bullock which the Keartons used as a hide. Dizzy from a long spell of gazing through a small peephole, Richard once lost his balance and caused the contraption to topple over; he had to wait an hour before being released (*Cherry Kearton*)

early photographic rambles, was himself taking pictures of tits, thrushes and robins in 1895, and he quickly became a very expert nature photographer. Deciding that there was no camera available which really suited his requirements, he set about designing and producing his own 'Bird-Land Camera', a sort of reflex camera that could be used not only from a hiding place, but for stalking birds as well. When it comes to technical improvements, the same ideas often crop up in different places, and a very similar model was developed at that time by Voigtlaender of Brunswick. Prototypes of reflex cameras were also being worked on in the United States.

Pike wrote many books and made use of a cine camera at a fairly early date. He was greatly interested in the cuckoo's strange habits, and in the May 1913 issue of *Wild Life* we find a series of pictures out of one of his films,

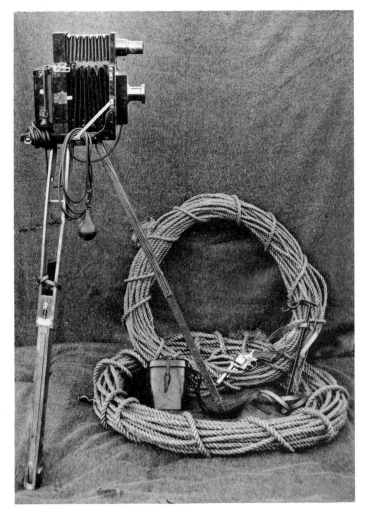

Richard and Cherry Kearton: Cameras and climbing equipment used by the Keartons during the nineties. The large half-plate camera was especially built for them by Dallmeyer. The camera on top was used to photograph flying birds or agile animals. Known as a miniature, it had little in common with the miniature camera of today. The revolver tucked into a coil of climbing rope served to flush cliff-inhabiting birds from their nests in order to locate the exact spot for descent (*Cherry Kearton*)

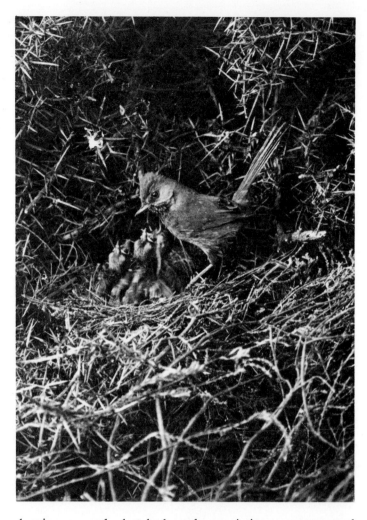

showing a newly hatched cuckoo evicting a young reed
warbler from the nest. It was probably the first time that
this life-and-death struggle between blind and naked nest-
lings had been recorded by what was then often referred to
as a 'bioscope camera'. Shortly after the First World War,
Edgar Chance began a systematic study of the cuckoo, and
Pike offered to obtain cinematographic evidence in support
of Chance's theory that the female laid her egg directly into
the fosterer's nest and did not carry it there in her beak.
Chance accepted, and Pike spent two months on the com-
mon that served as a study area enjoying, as he later wrote,
the most wonderful experience of his life and photographing
one of the first serious attempts at detailed ornithological
research.

 The cuckoo which Chance had under observation was

parasitising meadow pipits, of which there were thirteen
pairs on the common. To film the actual egg laying proved

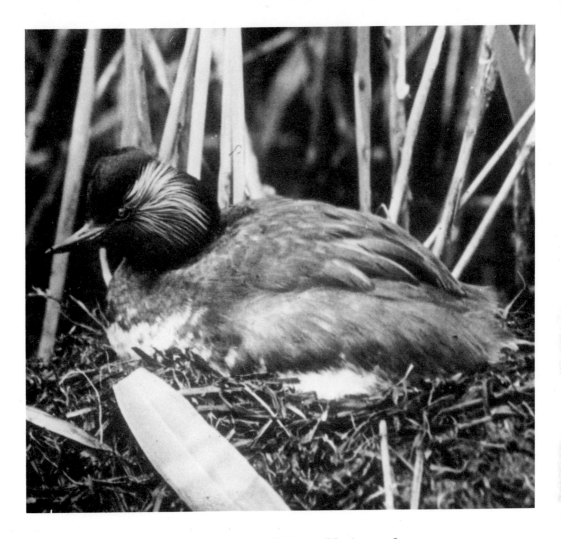

27

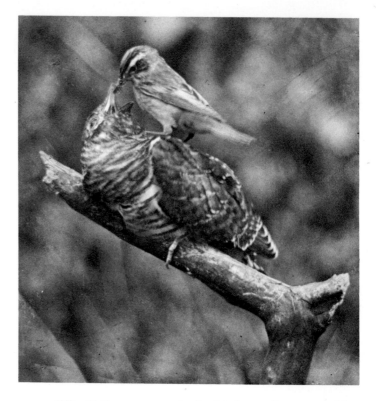

Oliver G. Pike: A young cuckoo brought up by robins is here seen being fed by a sedge warbler perched on its back (*Oliver G. Pike*)

more difficult than expected, the bird usually approaching the nest from the front and so covering her actions with her body. Having noted that she first settled on a tree or post within gliding distance of the nest about to be parasitised, Pike finally managed to place his hide at a right angle to the glide and got her in clear side view.

In 1900 there were in Britain 256 photographic clubs and an estimated four million camera owners. No wonder that nature photography took on in a most amazing way, with the Zoological Photographic Club coming into existence as early as 1899. During the following decade the clicking of naturalists' cameras could be heard in the remotest corners of the British Isles. Seton Gordon, armed with a Thornton-Pickard Ruby camera fitted with a Dallmeyer lens, began to turn his attention to the birds of the Scottish Highlands and islands. The excellent photographs taken by another Scot, Charles Kirk, became very well known in Britain and on the continent because Cowans and Grey Ltd made them available in their *Nature Books,* a series of low-priced but well produced paperbacks.

C. J. King, photographing seabirds and seals on the Scilly Islands, found that the black cloth he used while focusing on the ground glass screen acted as a hide; with no head visible, his subjects did not recognize him as a human being. An article by Wm. Farren of Oxford on the birds of the

Breck District, well illustrated with photographs, appeared in the July 1903 issue of *Animal Life and the World of Nature*. This was a magazine devoted mainly to 'Zoo Notes', accompanied by W. P. Dando's noteworthy camera studies of captive animals, and to natural history articles of a general character in which photographic material was used side by side with drawings and paintings.

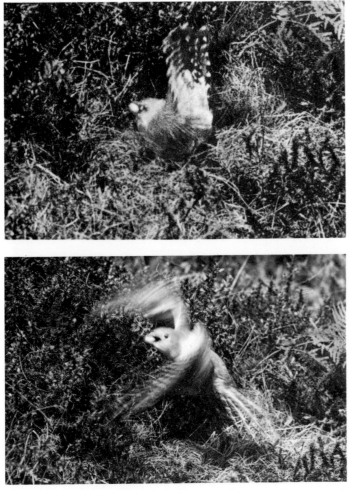

Oliver G. Pike: Cuckoo backing out of meadow pipit's nest after laying—and leaving with egg stolen from fosterers' nest
(*Oliver G. Pike*)

There appeared the first photographers' books devoted to just one bird or to a group of closely related species, such as H. B. Macpherson's monograph of the golden eagle and Bentley Beetham's *Home Life of the Spoonbill, the Stork and some Herons*. While Beetham obtained most of his pictures on the continent, Henry E. Harris went farther afield, taking a camera to the Canary Islands and to South Africa. His book, *Essays and Photographs* was published in 1901. It contains pictures of an amazing number of birds

Charles Kirk: Kittiwakes at Ailsa Craig (*Glasgow Art Gallery and Museum*)

and birds' nests, ranging from weavers, sunbirds and pied kingfishers to the Cape gannets and black-footed penguins of Bird Island and St Croix Island near Port Elizabeth.

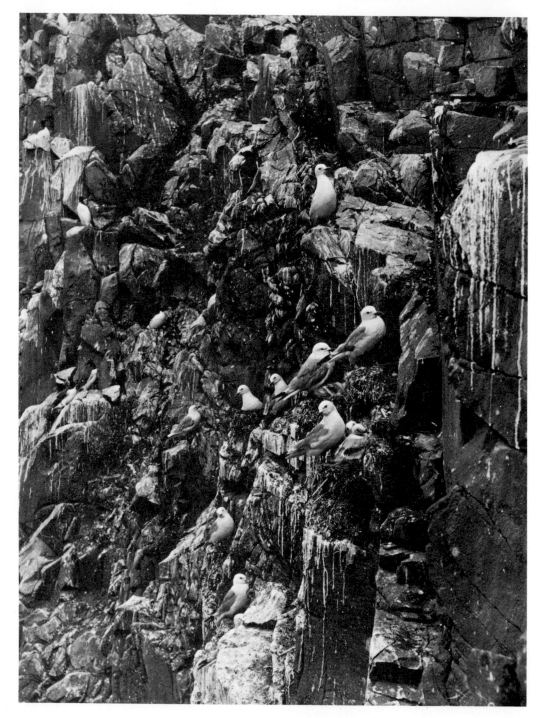

2 Pioneer Camera Hunting

Bird photography was quickly taken up by naturalists residing in distant regions of the British Empire. In 1911 two Scotsmen, the brothers R. A. L. and V. G. L. van Someren, brought out a beautiful portfolio of Ugandan birdlife. V. G. L. van Someren carried on this work for many years and became one of East Africa's foremost ornithologists. Many of his photographs have appeared in his valuable book *Days with Birds*; others in Praed and Grant's well known *Birds of Eastern and North-eastern Africa*. E. H. N. Lowther, born in India and educated in England, was a keen egg collector until 1906. 'On the last day of the Easter Term of that year', he tells us, 'Richard Kearton lectured at my school and persuaded me to give up egg-drill and blowpipe and photograph birds instead'. Returning to India to take up a post with the East Indian Railways, he began to devote his spare time to the subcontinent's rich and varied birdlife, an absorbing hobby, which for thirty-five years was to take his mind off the worries and care of his work and give him constant solace against the thought of retirement. Another early bird photographer in India was R. S. P. Bates, a military officer who published the first book on Indian birds illustrated entirely with photographs. Lowther and Lt-Col Bates later collaborated on a guide to the *Breeding Birds of Kashmir*.

Australia, with its wonderfully unique fauna, produced a good number of early nature photographers. W. G. and R. C. Harvey, J. S. P. Ramsey and R. T. Littlejohn can be numbered among these pioneers. The first authentic photograph of a 'wild' lyrebird may have been taken by A. E. (later Sir Albert) Kitson, who published it in the *Emu* of October 1905, but it was Littlejohn who later made a thorough pictorial study of this fascinating species. Two photographers who began their work about 1910, Charles L. Barrett and A. H. Chisholm, both attained great prominence as writers on Australian wildlife.

In the United States, bird photography was off to almost as early a start as in Britain, the first in the field probably being Frank Michler Chapman of the American Museum of Natural History. Dissatisfied with the way birds were exhibited in museums, each standing on its varnished board or perch, Chapman originated the 'habitat' method of exhibiting them in their natural surroundings. He strived for complete accuracy in every detail, and what better

method was there to achieve this than by working from photographs? Chapman therefore undertook a series of expeditions described in his very readable book *Camps and Cruises of an Ornithologist* and, operating mostly from blinds, he gradually accumulated a vast collection of photographs taken at close range. He studied birds around New York, on the Atlantic seacoast islands, in Florida, on the western prairies, in California and Canada. One of his most interesting experiences was a visit to Andros Island, one of the Bahamas, to observe and photograph the little known breeding habits of the flamingos. Chapman's pictures gave irrefutable proof that they did not sit straddling their nests

R. T. Littlejohn: Yellow robins. From Barrett, *An Australian Animal Book*

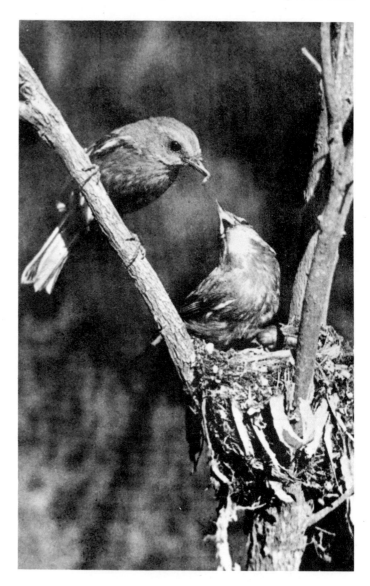

with legs dangling down, as had been assumed for two hundred years. Doubt had already been cast upon this statement by several ornithologists who had, however, failed to establish really intimate relations with the flamingos. Their observations, made from a considerable distance, were brief and fragmentary. No chicks, for instance, had ever been seen—and here was Chapman in his hide, sitting for hours within a few yards of the breeding birds.

While Frank Chapman found bird photography invaluable for his museum work, Francis H. Herrick, a professor of zoology, was led to it by an early interest in behavioural studies. He used a camera in order to record his observa-

Charles L. Barrett: Spotted cuscus. From Barrett, *Koonwarra*

tions of nesting habits and was probably the first photographer to use as a hide or blind a plain, uncamouflaged tent. He pitched it in July 1899 at the nest of a pair of redwing blackbirds and found that they paid not the slightest attention to the strange canvas structure which, one would have thought, should have appeared to them as a very disturbing blot in the landscape. From then on, Herrick took all his photographs from a tent. It seems, however, to have taken some time for the uncamouflaged hide to establish itself in Europe, for we find H. Meerwarth and F. C. Snell advocating the use of 'artificial trees' for bird photography as late as 1905. After the First World War, Herrick em-

Frank M. Chapman: Osprey settling on nest on Gardiner Island, New York (*The American Museum of Natural History*)

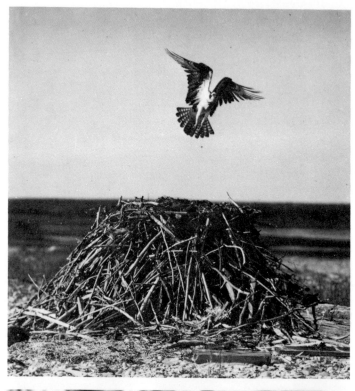

Frank M. Chapman: Breeding flamingos, Andros Island, Bahamas (*The American Museum of Natural History*)

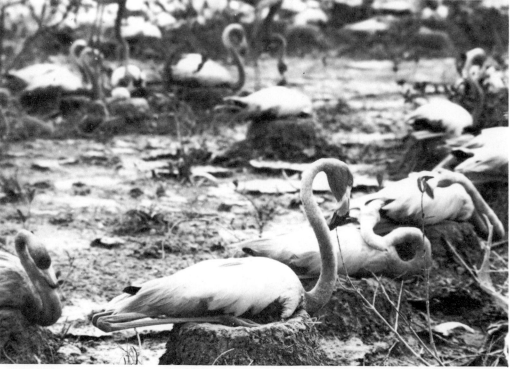

Francis H. Herrick: First use of an uncamouflaged tent as a photographer's hide; it was placed on a raft anchored in a swamp, close to the nest of a redwing blackbird (*Case Western Reserve University, Cleveland, Ohio*)

barked on a major study of the American bald eagle, now very rare or extinct in many parts of the United States, setting up his tent thirty-eight feet from an eyrie at Vermilion, Ohio, on top of an eighty-foot steel tower. Frank Chapman very quickly adopted Herrick's canvas hide, and in due course developed it into the handy, easily pitched 'umbrella blind'.

If we disregard James Chapman's South African endeavours and a few early photographs of deer taken in European parks and game preserves—for instance by Ottomar Anschütz and Bernhard Johannes—systematic 'camera hunting' for big game seems to have originated in the United States. A. G. Wallihan, having decided to photograph the mule deer, wapiti, prongbuck and mountain sheep of Colorado and Wyoming, had no success with deer in 1889, but got a few passable negatives a year later. Cameras suitable for this kind of work were very heavy and had to be used on tripods. Many chances were lost through the time taken to set up the unwieldy photographic apparatus, but it did not take long for Wallihan to improve his equipment. In 1894 he added to it a Zeiss Series II lens for greater speed, and this gave him excellent results. Several times he went out with professional hunters and secured photographs of cougars and bobcats treed by hounds. He snapped one cougar in mid-air as it launched itself out from

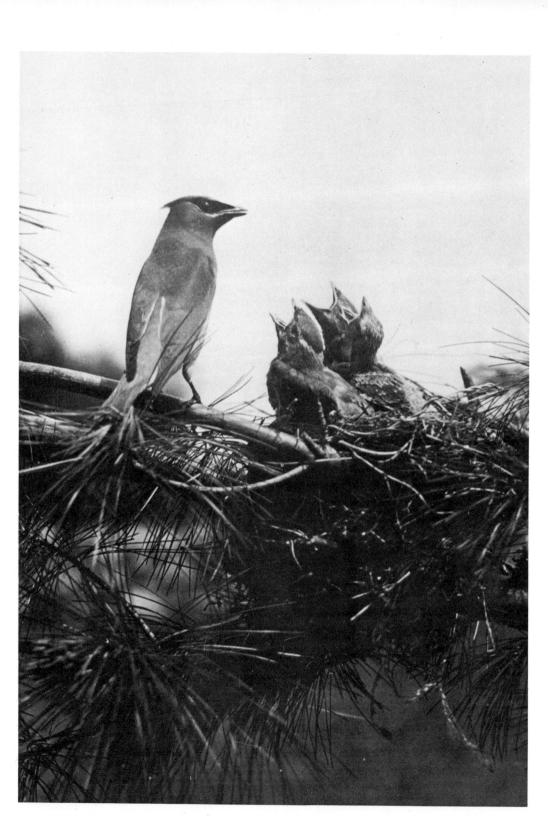

a branch to land within six feet of the camera-hunter armed with nothing more lethal than a pocket knife. Wallihan was ably assisted by his wife—the two, in fact, forming the first of the husband-and-wife teams which were to play a part in wildlife photography. Mrs Wallihan herself took many pictures and was co-author of *Camera Shots at Big Game* which was published in 1901 with an introduction by Theodore Roosevelt.

A. G. Wallihan: Portrait of a young wapiti stag. From Wallihan, *Camera Shots at Big Game*

Roosevelt also showed great interest in the photographic efforts of George Shiras III, a lawyer by profession who owned a hunting camp at Whitefish Lake in northern Michigan. Tiring of shooting, Shiras exchanged the rifle for a camera. First endeavours to photograph white-tailed deer in 1889 ended in failure, but Shiras repeated his attempts during the following year and obtained several pictures of fair quality. The focal length of his lens was rather too short and he found that he had to get to within twenty-five feet of his subject for really satisfactory exposures. Shiras therefore tried various methods other than stalking, such as waiting in a blind, operating a camera from a distance by pulling a string or setting trip-wires in order to have the shutter released by the animals themselves. Having occasionally hunted deer at night by means of a jacklight, Shiras began to speculate upon the possibility of photographing animals in the dark. He spent years experimenting

Francis H. Herrick: Cedar waxwing at nest (*Case Western Reserve University, Cleveland, Ohio*)

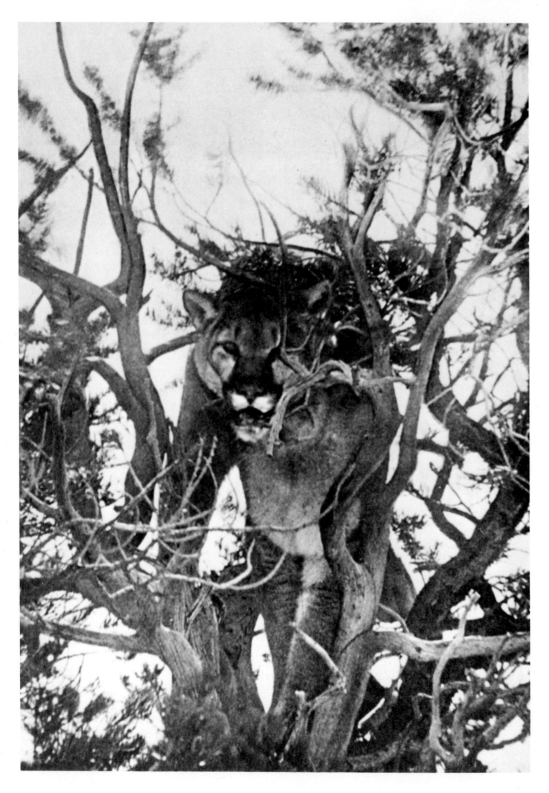

with a variety of flashlight devices, all of his own design, for nobody had yet done any work of that nature. For taking photographs from canoes silently cruising on northern Michigan or Canadian lakes and rivers he constructed a flash mechanism that could be held in one hand and triggered like a pistol. It gave him excellent snapshots of moose, wapiti and deer. On one occasion he obtained a magnificent portrait of a lynx sitting close to the water's edge. Shiras also improved the trip-wire system originally used for daylight pictures to the point where he could get animals to take their own photographs by automatic flashlight. He was very successful with white-tailed deer, and his 'Midnight' series of photographs won him a Gold Medal and Recommendation at the 1900 Paris World Exhibition.

George Shiras: Doe white-tailed deer with twin fawns taken in 1896—one of the famous 'Midnight' series of flashlight photographs awarded a Gold Medal at the 1900 Paris World Exhibition (*National Geographic Society*)

(*opposite*) A. G. Wallihan: Cougar—also known as puma or mountain lion—photographed after having been treed by a pack of hounds. From Wallihan, *Camera Shots at Big Game*

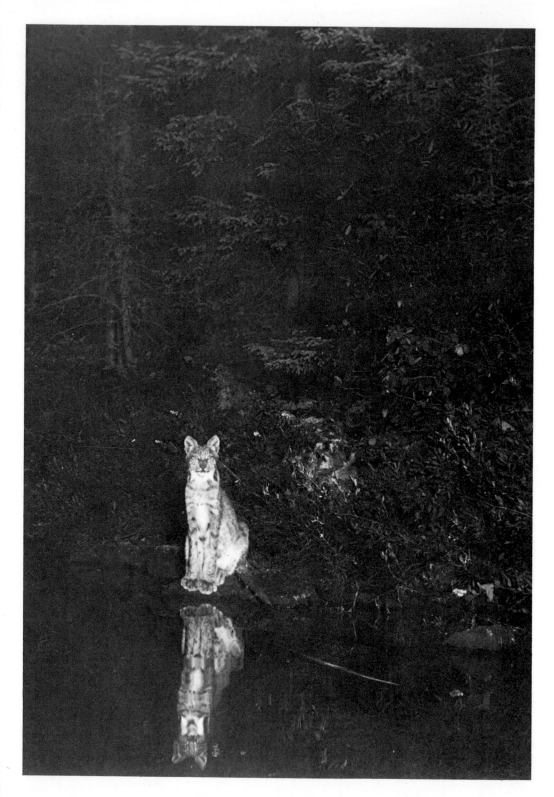

George Shiras: Lynx at
Loon Lake, a flashlight
photograph taken in 1909
(*National Geographic Society*)

George Shiras: Bull moose
on the bank of Loon River,
a flashlight photograph taken
in 1909 (*National
Geographic Society*)

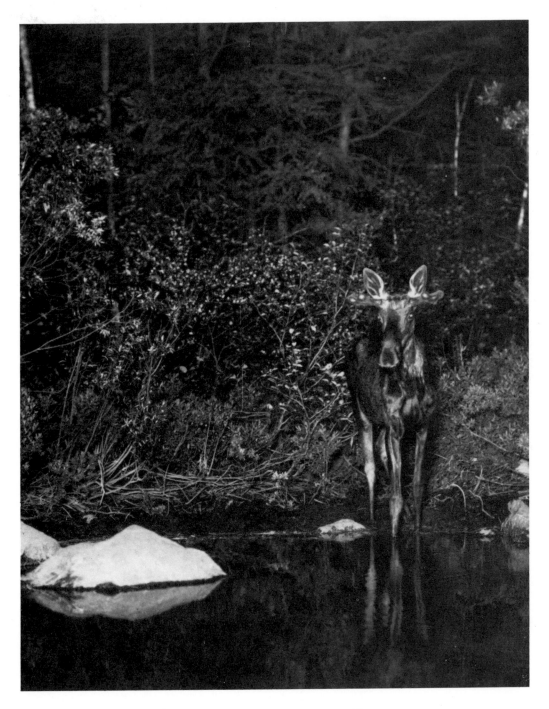

With greatly improved cameras for daylight work, Shiras spent the years up to 1935 photographing animals and birds all over northern and central America. He turned his lenses upon moose in New Brunswick, caribou in Newfoundland, mule deer in Arizona, giant moose and Dall sheep in Alaska; he explored the upper reaches of Yellowstone River and discovered the subspecies of moose which now bears his name; he studied and photographed the birdlife of Florida, Louisiana, eastern Mexico and the Bahamas. A trip to the Canal Zone of Panama gave him a fascinating glimpse of the Tropics.

From 1908 on Shiras published the results of his expeditions in the *National Geographic Magazine.* As early as 1906 Theodore Roosevelt had urged him to bring out a book in which could be published his pictures as well as his invaluable field notes on the habits not only of game animals, but of innumerable other creatures as well. Shiras did eventually produce this book, and it was published by the National Geographic Society in two lavishly illustrated volumes in 1935—unfortunately long after Theodore Roosevelt's death.

William L. Finley took up bird photography around 1902, assisted by H. T. Bohlman and working mostly from natural hiding places or with birds that had become used to the photographer's presence. He obtained striking results. One amazingly good snapshot of a hovering hummingbird, taken in 1905, was used in a book on bird flight a quarter of a century later. In 1906, Finley studied a pair of California condors. He took portraits of the parent birds perched near their nesting site, and he also got them in flight, braking hard as their twenty to twenty-eight pounds went hurtling towards their landing place.

It was in 1914 that Arthur A. Allen snapped his first photograph of a bird, a ruffed grouse sitting on its nest. He later became Professor of Ornithology at Cornell University and made the widest possible use of camera and hide as instruments for scientific bird study. In his *Book of Bird-Life,* first published in 1930 and reprinted many times since, Allen tells us that in those early days he mostly used a 4 x 5 Corona View Camera, fitted with a 10in Zeiss Tessar II B lens, aperture f/4.5 to f/6.3. The Graflex he found too noisy while working from a hide, but invaluable for taking flight pictures.

An early specialist in 'stopping' birds in mid-flight was Howard H. Cleaves, whose picture of an osprey making an unsuccessful strike at a 30cm-long dummy fish can be rated as a classic. His action shots of barn swallows and of a belted kingfisher shooting out of its nesting hole are among the best of this kind taken before the advent of high-speed flash.

In continental European countries, occasional exposures

were made during the eighties and early nineties of deer
and other game animals, and also of easily approachable
birds such as white storks, but on the whole naturalists seem
to have become aware of the possibilities of wildlife photo-
graphy mainly through the work of the Keartons. I have
in front of me a letter from Herr Hermann Fischer, one of
the early German camera-hunters, and he writes: 'I first
heard of animal photography around 1898, of the Brothers
Kearton who used the stuffed skin of an ox as a hide'.

In 1897, a Leipzig firm of publishers brought out a book
on the game animals of Central Europe with a text written
by Prof W. Wurm, a very competent zoologist, and illus-
trated throughout with 'instantaneous photographs from
life'. The pictures, which the publishers evidently considered
to be the volume's main attraction, came from a variety of
sources. Some were quite obviously of stuffed game birds

Fr Grainer: An early photo-
graph of a chamois taken in
the Bavarian Alps during the
mid-nineties. From Berg-
miller, *Erfahrungen auf dem
Gebiet der hohen Jagd*

placed in natural settings; many had been taken in zoological gardens, especially by Ottomar Anschütz, a professional photographer who, by that time, had attained prominence in this kind of work. Anschütz also contributed some portraits of red deer, taken in 1889 in a German game preserve. There were a few notable photographs of European elk by Baron von Krüdener, a well known writer on shooting topics; of roe deer by the Duke of Ratibor; and of Alpine red deer, chamois and ibex by Fr Grainer, a professional photographer from Bad Reichenhall in Bavaria. Grainer must have been in the field fairly early, for a few of his photographs had already appeared in an English book on Alpine sport published in 1896. The idea of hunting animals with a camera was, however, soon to be given a very forceful stimulus—a stimulus that, of all places, came from the faraway game areas of eastern Africa.

C. G. Schillings: The photographer in his safari kit (*Schillings Archiv, Düren*)

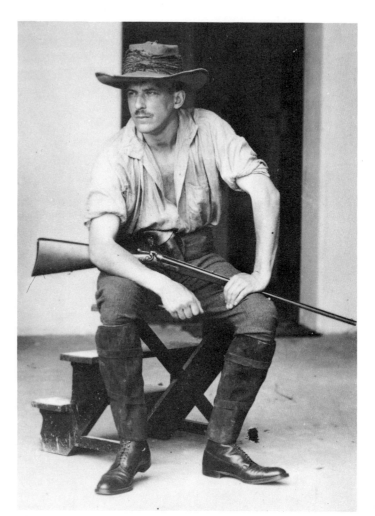

For a very long time nobody had tried to follow in James Chapman's footsteps. A first attempt in that direction was eventually made during Lord Delamere's 1896-7 exploring expedition from Berbera in Somaliland to British East Africa. A professional photographer attached to the party got a few snapshots of elephants, reticulated giraffes, Grant's gazelles and Grévy's zebras in the Rendile country of what is now northern Kenya. Edward North Buxton, shooting in East Africa during 1899, very much regretted not having brought a camera suitable for taking pictures of the fabulous game herds. On his next expedition which took him up the Nile to the Sudan, he equipped himself with a Dallmeyer Naturalist's Camera, and without having had any previous experience, obtained some quite remarkably good exposures of hippo, white-eared kob, waterbuck and tiang, as well as of jabiru storks, pelicans and other birds. When these pictures were published in 1902 a German sportsman, Carl Georg Schillings, was in the midst of an all-out effort to produce a comprehensive pictorial record of East African wildlife.

Schillings, the son of a well-to-do landowner of Düren in the Rhineland, travelled through British East Africa in 1896 and 1897 as a member of a scientific expedition. He shot lions near the site of present-day Nairobi and found himself marvelling at the vast herds of game which surpassed anything he had dared to expect. The wilderness he traversed was practically untouched but Schillings thought of what had happened to similar concentrations of wildlife on the American prairies and on the high veld of South Africa. He knew that British engineers, assisted by an army of Indian coolies, had just begun to build a railway that was to link the harbour of Mombasa on the Indian Ocean with Lake Victoria, and he shuddered at the thought that the line would be passing through these arcadian game fields. He naturally could not know that the colonial administrators of the day were determined to preserve as much as possible of East Africa's wildlife and that more than seventy-five years later there still would be enough left to attract thousands of tourists.

Back in Germany, Schillings gave a vivid account of what he had seen to Professor Ludwig Heck, director of the Berlin Zoo. Heck, too, was aware of the dangers threatening the game animals of the East African plains. Would it be possible to at least secure photographs of these wonderful scenes before it was too late? The Professor had a feeling that Schillings might be the man to tackle such a task, and he implored him to go back to Africa and to use a camera in preference to a rifle. Schillings was hesitant at first, for with his firsthand experience of African travel and hunting he could fully appreciate the difficulties involved in the undertaking suggested by Professor Heck. He finally gave

C. G. Schillings: One of his telephoto-cameras (*Schillings Archiv, Düren*)

in, took a technical course at a photographic institute and in 1899 went out to the game country north of Kilimanjaro, part of which we today know as Amboseli National Park. He was equipped with the most up-to-date cameras and best flashlight apparatus the German firms of the time could provide, but the difficulties proved even greater than he had anticipated. He did get some quite satisfactory daylight pictures of game, but his flashlight equipment broke down completely, and he later wrote: 'It was a very unpleasant hour when I made the discovery that my heavy and expensive accumulators had lost their power and I distinctly remember how I flung them far out into a river.'

Two years later Schillings was once more on his way to Kilimanjaro, armed with telephoto lenses similar to the ones Buxton had used on the White Nile. These lenses absorbed a considerable amount of light, necessitating long exposures. They were well suited to photographing stationary objects, but in shooting walking animals or flying birds, the photographer had to follow as if he were using a shotgun, thus getting a completely blurred background. Their depth of focus was very shallow and, for adjusting the distance, Schillings more often than not had to depend on pure guesswork. There already existed some long-focus lenses which admitted somewhat more light, but they were big and heavy, and handling them was a laborious business,

46

especially under the conditions prevailing in the African bush. Working extremely hard, Schillings accumulated a large collection of tele-photographs but his very best pictures, of two bathing rhinoceroses, were taken with a small hand-camera at a distance of fifteen paces. The new flashlight equipment did not come up to expectation, mainly because the device for firing the magnesium powder was not properly coupled with the shutter. This had to be left open when the camera was set up and clicked shut after the flash had gone off. The first satisfactory night picture was of a mongoose, and there followed some exposures of hyenas and jackals. Only too often, however, the plate revealed a jackal with six heads or a hyena as long as a python.

A severe attack of malaria forced Schillings to cut short his expedition. Soon after his return to Germany he became acquainted with M. Kiesling, who had taken up flashlight photography and constructed a device that fired the flash and released the shutter at exactly the same moment. Schillings was almost glad that fever had prevented him from wasting more time with inadequate equipment.

A third photographic expedition in 1903 and 1904 finally brought the fulfilment of the task Schillings had set himself although this safari, too, had its full measure of disappointments. It took several months to get the flashlight apparatus, which had appeared so foolproof in Europe, into proper working order. The flashpowder, which Schillings had to mix in a mortar immediately before use—a very risky operation—was ruined by rain and dew when not properly protected; mongooses stole the aluminium plate-holders and carried them to their burrows. The cameras themselves were not absolutely lightproof and could only be set up at dusk. Finding it impossible to sit up night after night, Schillings adopted the same method as Shiras and arranged his flash-light device in such a way that it was released by the animals themselves. Flashes in the middle of the night again and again raised high hopes, but when the plates were developed, nothing could be seen, some night bird, bat or large beetle having touched the trip-wire and fired the magnesium powder. Particles of the cloth used to protect the apparatus against humidity were sometimes torn off by the force of the explosion and set alight in front of the lens, ruining what might have been a perfect picture. If the flash did not go off during the night, the plate-holders had to be removed before dawn to prevent the plates from fogging.

Schillings was tempted more than once to drop the whole tedious business but he continued and his perseverance at last found its long-overdue reward. His photographic plates began to reveal pictures of gazelles, impala, wildebeest, zebra and rhino coming to the water, perfectly in focus and brilliantly lit. Hyenas and jackals took their own portraits, fighting over a bait. We can easily imagine Schillings' elation

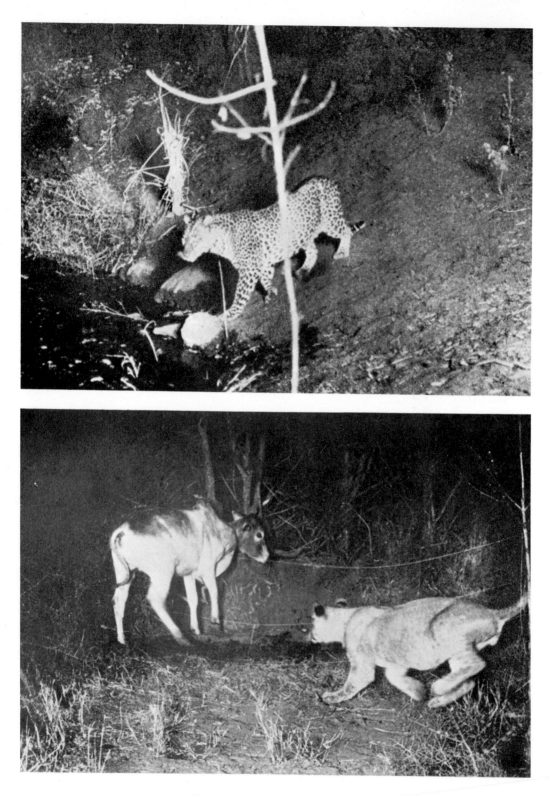

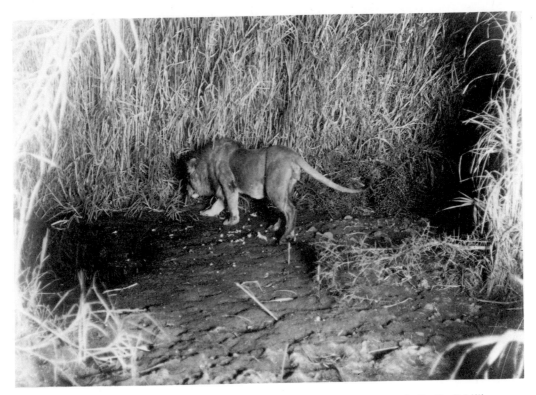

(*above*) C. G. Schillings: Male lion approaching a waterhole (*Schillings Archiv, Düren*)

when he was able to write in his diary: 'Almost exactly at midnight my flashlight apparatus gave me a really hard-to-get nature document: The picture of a magnificent leopard —a big old male.'

Ever since he had turned to animal photography, it had been his great ambition to obtain a pictorial record of the nocturnal life of the lion and here, too, success came his way. The first lion picture was of a female walking away, tail stretched out straight as a ramrod, after having killed a donkey tied out as a bait. On another occasion, three lions were stalking a bull, and the flash lit up the scene as a lioness rushed forward for the kill. So much control did she have over her body that—as another camera revealed—she managed to swerve off in the middle of her rush without ever touching the animal. On one plate there appeared a lioness stalking a donkey from behind, on another three lionesses drinking at a stream—one with her head lowered to the water, the second looking up in surprise and the third caught in the act of throwing herself around to run away. One morning, after having developed the plates exposed during the night, Schillings summed up the result as follows: 'What I never dared hope for has become fact: An old male lion, the most magnificent predator on earth, approached the water of the swamp and gave me my finest photographic trophy.'

(*above*) C. G. Schillings: Male lion approaching a waterhole (*Schillings Archiv, Düren*)

(*opposite above*) C. G. Schillings: Flashlight photograph of a big male leopard. From Schillings, *With Flashlight and Rifle*

(*opposite below*) C. G. Schillings: Lioness rushing at a bullock; frightened by the flashlight, she swerved off in mid-stride and ran away without having touched the beast. From Schillings, *With Flashlight and Rifle*

Schillings' hard-earned photographs—assembled in two volumes produced by R. Voigtlaender of Leipzig—caused a tremendous sensation, and it can be said without exaggeration that in Germany it was their publication that really and truly put 'camera-hunting' on the map, with all the photographic journals of the day indulging in a spate of articles on the subject.

African travellers and hunters suddenly found themselves encouraged to make wider use of their cameras, which hitherto had mainly served to snap landscapes, natives and trophies, and some of them were quite amazingly lucky. While Schillings himself had never obtained a really satisfactory photograph of an elephant, Hans Paasche, a naval officer seconded to the German East African defence forces shortly after Schillings' last expedition, came upon a small herd which let itself be photographed at close range. Handing his camera to his NCO, Paasche had himself snapped together with one of the giants. Hans Schomburgk and James McNeil, two elephant hunters making their way from Southern Rhodesia to German East Africa, began taking game pictures with a hand-camera. Towards the end of their expedition they stalked up to within about twelve paces of a bull elephant and Schomburgk, covered by McNeil's rifle, got a photographic classic as the animal turned round with ears spread out. While hunting and collecting in East Africa prior to the First World War, Dr E. Gromier, the French naturalist, had considerable success with an ordinary 9/12 Klapp camera, even though he at times thought of his photographic efforts as an 'occasion of lost chances'.

Acknowledging inspiration directly to Schillings, Jasper von Oertzen, a German officer stationed in Cameroon, accumulated a fairly elaborate photographic outfit which included telephoto lenses. He obtained some interesting shots of birds, but was less successful with buffaloes and antelopes. Von Oertzen therefore began to keep animals— monkeys, duikers and other forest antelopes, warthogs, civet cats, even lions, leopards, cheetahs and striped hyenas —in a sort of semi-captivity that enabled him to study and photograph them as they moved about in their natural habitat without, however, showing the slightest trace of fear. He made no secret of this method, and the resulting observations and animal portraits from an area not yet visited by any other wildlife photographer were greatly appreciated by zoologists.

Another German, Dr A. Berger, made an even more determined effort to follow in Schillings' footsteps. On an expedition through northern Kenya and Uganda he used a Goertz reflex-camera and brought back photographs of zebras, antelopes, giraffes and rhinos of such fine quality that Schillings, now an honorary Professor of Zoology, wrote a very laudatory foreword to his successor's book.

The English language editions of Schillings' works found considerable acclaim in Britain and America. They earned their author a hearty letter of congratulation from Theodore Roosevelt and were read with very special interest by an Englishman, Arthur Radclyffe Dugmore, who had become widely known, especially in the United States, as an animal artist and wildlife photographer. Dugmore was the son of an army officer who one day threw up his career, bought a sea-going yacht as a home for his family and took to roaming the Mediterranean and the Atlantic, driven by the constant hope that something might 'turn up'. Arthur never quite forgave his father for not having allowed him to get any formal schooling, but life at sea may well have done more for him than any number of schoolmasters. At the age of eighteen he certainly was mature enough to be offered a post as secretary to His Excellency the Governor of British Honduras. The retired Colonel, considering his son as much too young for such a responsible position, said 'No', and the Dugmores moved to Florida.

When one more of his father's many schemes went awry, Arthur left the family and set himself up as a professional photographer at Tarpon Springs. Through some friends he met W. E. D. Scott, a well known ornithologist who forthwith employed him as an assistant. Dugmore spent two years collecting and preparing bird specimens. He went to New York in 1892, and it may have been the memory of his father's constant search for the pot of gold at the rainbow's end that made him settle down in a very well paid job as a mechanical draughtsman. He dropped it without hesitation, however, when Scott asked him to photograph birds for a book he was doing. Dugmore thus embarked upon the career he was to follow for the rest of his life and in which he soon attained great prominence. While taking photographs for another book—*American Animals* by Stone and Cram—he obtained one of the most delightful pictures ever taken of a small mammal, showing a white-footed mouse suckling her young. While the photographer was packing up his equipment the mouse, unnoticed, slipped into his pocket. When he discovered it there, Dugmore ran back a mile to restore the mother to her family.

Dugmore made several trips to Newfoundland for pictures of migrating caribou. He photographed jumping salmon, the fabulous wapiti herds of Jackson's Hole, studied the beaver at work, portrayed the habits of the tree porcupine and the opossum. In between photographic ventures he wrote one of the earliest manuals of nature photography— *Camera and Countryside*. He had several cameras built to his specifications and they served him very well. An expedition after moose, however, which he was asked to undertake in order to try out a new type of reflex-camera designed by a famous firm brought disappointment. Light leaked into

the camera which had been handed to him at the very last moment with the solemn assurance that it had been tested by an expert, and almost every plate was fogged. 'It taught me,' Dugmore wrote of the incident, 'that it is never safe to use any camera that I have not proved personally to be in perfect condition'—and this is as true today as it was in those pioneering days. A second trip after moose in 1906 brought splendid results.

Dugmore had long been fascinated by Africa and, having read Schillings' books, he decided to go and see what he could achieve among the lions and rhinos. The financing of this enterprise was helped along considerably by the an-

A. R. Dugmore: Worm-eating warbler feeding her young on the hand of the photographer, who released the camera shutter with his left hand (*Neill Bruce Photographic*)

nouncement in the press that Theodore Roosevelt was going to lead a scientific expedition to British East Africa. Any material Dugmore might secure would thus be of considerable news value and, before he even left the United States, a very welcome order came from *Collier's Magazine* for a series of articles. As a companion he took along James L. Clark, a young taxidermist working at the American Museum of Natural History, who was willing to pay his own way and to stand by with a rifle while Dugmore took photographs. Clark, who performed this task splendidly, later went back to the museum and worked his way up to become Director of Preparation and Installation.

Dugmore and Clark arrived in Mombasa in January 1909 and went up to Nairobi by train. In the five years since Schillings' last expedition progress had been made in optical science and camera design, but Dugmore's favourite reflex-camera was still a huge, bulky box, and one has to admire the stamina of the man who managed to walk for hours under the African sun with this weighty piece of furniture hanging around his neck. The lens which stuck out of the contraption like a young cannon was, however, somewhat faster, with greater depth of focus and better definition than any of the lenses Schillings had been able to use.

Dugmore and Clark made a trial safari to the Olgeri River and had their first encounters with rhinos. One day they watched one of these animals lying down under a bush. 'Such a good chance for some close work was just what I had been hoping for,' Dugmore wrote, 'and so after waiting until we were sure he was soundly asleep, I changed the telephoto lens for another regular quick one and started forward with utmost care. My companion, with his .450 rifle, was immediately behind me, and the camera bearer and Masai a little further back. As quietly as possible we stalked the sleeping creature until at thirty yards we were close enough for all practical purposes. My companion stood slightly to one side, and I made some noise. Like a flash the big animal was up and without waiting a moment he headed for us with tail erect and nostrils dilated, snorting as he came. It was a splendid sight, but not one to linger over. I was watching him on the focusing glass of the camera, and when he seemed as close as it was wise to let him come, I pressed the button and my companion fired as he heard the shutter drop. The shot struck the beast in the shoulder and fortunately turned him at once. At the point of turning he was exactly fifteen yards, but it seemed more like five.' The resulting photograph is still one of the most dramatic ever taken of a charging rhino.

Having returned to Nairobi, Dugmore and Clark visited the Yata plains, crossed the Tana River and then went north via Fort Hall, Nyeri and Meru to the Uaso Nyiro, from where they made their way back to Nairobi by about

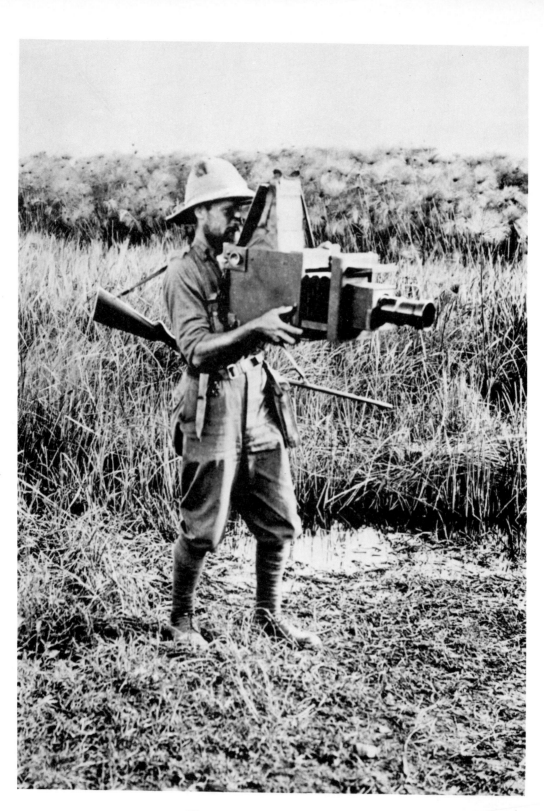

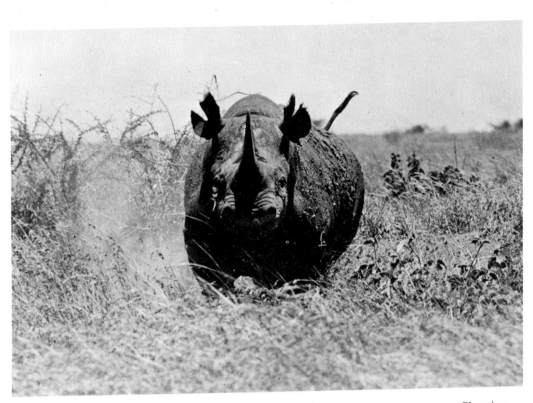

the same route. In the course of his expedition Dugmore was successful in securing many tele-photographs of rhino, hippo, warthog, Grant's gazelle and Grévy's zebra, buffalo, giraffe and various antelopes, including gerenuk and beisa. He even took the first-ever photograph of the giant forest hog, a species that had been discovered a few years previously.

As far as his flashlight apparatus was concerned, Dugmore at first experienced almost as much trouble as Schillings had, and only after having been re-designed several times did the outfit give him fairly reliable service. He did not rely on trip-wires, finding it preferable to release flash and shutter from the shelter of a boma, an enclosure constructed of thorny branches. Together with Clark he sat up for no less than fifty nights during the safari.

Near the Tana River, Dugmore shot a zebra as bait for the lions which had been roaring around the camp. A couple of cameras were brought into position covering the dead zebra from different angles, and Dugmore then took the first watch. Suddenly he became aware of a male lion standing over the carcase. He had heard nothing, noticed no movement—the animal was simply there all at once, twelve yards from the boma and apparently staring straight at the photographer. Dugmore groped for his sleeping companion and whispered 'Lion!' Clark fortunately woke up without making a sound, leant over and looked at the big

A. R. Dugmore: Charging black rhinoceros photographed at a distance of fifteen yards—probably the most famous rhino picture ever taken (*Neill Bruce Photographic*)

A. R. Dugmore: The photographer carrying the reflex-camera with which he took all daylight photographs on his first African expedition; it weighed 16lbs without plates (*Neill Bruce Photographic*)

55

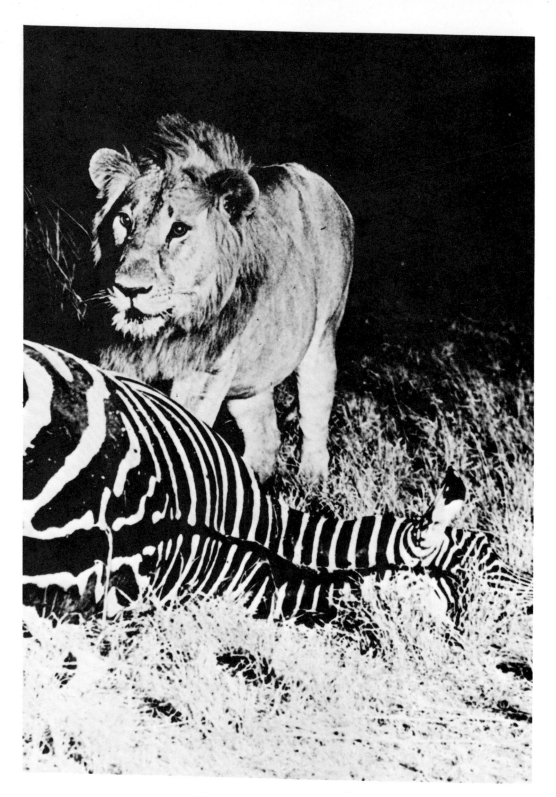

cat. With bated breath, Dugmore pressed the electric button —a blinding flash—the lion ran about a hundred yards and began to roar. A second lion joined him, and for a while the two kept up a thunderous duet. Dugmore nevertheless crept out of the boma, changed the plate-holders and reset the shutter. The rest of the night, however, passed without further incident. Back in camp, Dugmore almost trembled with excitement as he began to develop the plates—he knew from long and painful experience how much could go wrong in photography. But when he took the plates out of the development dish, he had two wonderfully clear negatives.

On another occasion, circling vultures led Dugmore and Clark to a dry river bed, where they found the remains of a hartebeest killed by lions. Dugmore set up three cameras connected with one another and with the flashlight apparatus by means of electric cables. Night had hardly fallen when the lions arrived. They looked like phantoms, their tawny bodies hardly visible against the yellow grass. Dugmore turned his torch on them and the beam caught a lioness slowly approaching the kill. In the strong light her eyes shone like jewels, and the photographer was so fascinated by the beautiful sight that when she entered the area covered by the camera lenses he for a moment forgot to press the button. Suddenly he remembered why he was sitting in the boma, and the flashlight went off with a bang.

A. R. Dugmore: The photographer setting up his flashlight equipment at a lions' kill (*Neill Bruce Photographic*)

A. R. Dugmore: Flashlight photograph of a male lion standing over a zebra bait taken in 1909 (*Neill Bruce Photographic*)

Growling, the lioness withdrew. Dugmore and Clark left the boma to reload and reset the cameras. They both felt greatly relieved when they had regained the safety of their enclosure.

After about two hours the lioness came back. When she was only ten yards from the boma, standing broadside to the cameras, Dugmore fired the flash. She jumped back growling and once more the two men had to venture forth into the night, armed with torches and rifles. For hours the lions roared all around without approaching the kill. Eventually some came nearer, growling and snarling, and all at once a lioness jumped into the river bed and walked to the remains of the hartebeest. Again the flashlight flared up, and the lioness withdrew snarling. After the many hours of high tension, watching the gorgeous tropical dawn was almost a relief. Dugmore hurried back to camp as fast as he could and shut himself up in his improvised darkroom. 'No words can express my delight as negative after negative came up clear and crisp, and I found that all were satisfac-

A. R. Dugmore: Migrating Newfoundland caribou crossing a river (*Neill Bruce Photographic*)

tory beyond my most sanguine expectations,' he tells us.

Apart from lion pictures, Dugmore obtained flashlight photographs of hyenas, jackals and of hartebeests coming to the water. He was later to sum up the results of his safari in the following words: 'In every way it had been better than I believed possible. I had secured photographs of 24 species of game and seen 38 species as well as many birds. We had had no illness and no accidents. Everything, in fact, had gone as well as possible. But I was thoroughly tired out. Scarcity of money had made it necessary for me to work far harder than was desirable. There had been no opportunity for resting during the four months we had been in

the field. I had walked altogether about fifteen hundred miles—nearly four hundred miles per month. All my photographs had been developed and printed in camp, several articles written, and a large amount of interesting information collected on animals, birds, natives and the country. So I felt that the expedition was a success.'

Dugmore's book *Camera Adventures in the African Wilds* at once put him in the first rank of animal photographers. Strenuous as the safari had been, Dugmore nevertheless went off immediately to Newfoundland for more pictures of caribou. He had decided to make this animal the subject of a comprehensive monograph, as other photographers had devoted books to single bird species. He wrote *The Romance of the Newfoundland Caribou* after having moved to Britain with his wife and children, and it was followed in 1914 by *The Romance of the Beaver*.

The War Office, so often accused of trying to fit square pegs into round holes, certainly found an appropriate use for Dugmore. With the rank of major he was appointed to

Big game photography as seen by *Punch* in 1907

PHOTOGRAPHY IN THE WILDERNESS.

DISAPPOINTMENT AND DISGUST OF SNAPPITT AND POPLEIGH, WHO HAVE BEEN STALKING EACH OTHER FOR HOURS.

teach and train picked men, mostly gamekeepers and poachers, as scouts—stealthy hunters of men. He survived the carnage of the Somme but was invalided back to England after a phosgene-gas shell had exploded less than two yards from him. Recovery was slow, but a few years after the end of the war, Dugmore was again photographing and painting animals. He returned to East Africa, this time armed with a cine-camera, and filmed the game herds of Ngorongoro—rhino, reticulated giraffes and zebras drinking at the waterholes of northern Kenya, elephants at Marsabit.

Next he made a movie record of the native tribes and game animals of the Sudan, and while engaged upon this work he was very nearly caught by a member of a huge herd of particularly aggressive female elephants known as the 'suffragettes'. The animals were in thick bush, and it took the photographer some time to get within about sixty yards of a cow and calf which happened to be in a fairly open place. Dugmore set up the camera and began to turn the handle. The cow almost immediately raised her trunk and spread her ears. A charge seemed imminent, and Dugmore put out one hand for his rifle. Realising that the gunbearer had run away, he simply went on filming, while the cow began to move in his direction. She came slowly at first and then rushed forward with bloodcurdling screams. Dugmore cranked away until she was scarcely twenty yards from him. The moment he turned to run, intending to throw himself behind a bush and let the animal go past, the elephant swung round in the opposite direction and made off.

In 1928, Dugmore re-visited North America, filming bighorn sheep, mule deer and wapiti in the Canadian rockies.

It appeared to H. Meerwarth, the German photographer, that the many articles on nature photography which followed close upon the publication of Schillings' pictures, even though dealing exhaustively and conscientiously with such topics as focal lengths and exposure tables, gave very little information on how actually to 'hunt' with a camera. He therefore translated Dugmore's manual and brought it out in 1905, adapted to European conditions and enlarged by a number of chapters detailing his own experiences in photographing roe deer and other game. It may well have been at Meerwarth's instigation that Schillings' publisher, R. Voigtlaender, started a photographic competition calling for material that could be used in a series of books devoted to the wildlife of Europe. Meerwarth was asked to act as photographic editor, with zoologist Karl Soffel as scientific adviser.

The first handsomely produced volume came off the press in 1909, and it was followed in quick succession by several others. In the case of animals occurring on both sides of the Atlantic, photographs of their North American repre-

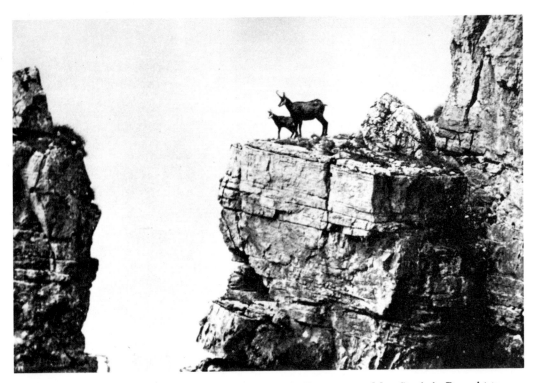

Max Steckel: Brought to their feet by the photographer's whistle, the chamois mother and her kid stood out beautifully against the sky. From Meerwarth and Soffel, *Lebensbilder*

sentatives were considered as acceptable, and Dugmore therefore found himself well represented with pictures of caribou, wapiti and moose. Meerwarth himself contributed studies of foxes and wild rabbits. There were remarkable shots of brown bears by Egon von Kapherr and Count Eric von Rosen, and of polar bears taken by A. Leverkus on his 1907 expedition to north-eastern Greenland. M. Behr submitted photographs of seals, badgers and especially of European beavers, to the study of which he was to devote a large part of his life. One of the main contributors was Max Steckel who had taken up animal photography in 1896, mainly with cameras of his own design. From his collection Meerwarth was able to select excellent studies of red deer, roe deer, European elk, chamois, ibex and wild boar.

Photographs of chamois were particularly difficult to obtain and, on his first visit to Prince Hohenlohe's hunting preserve among the Tatra Mountains, Steckel worked hard for two solid weeks without exposing a single plate. He often heard the animals high up on the cliffs without being able to catch sight of them, and stones loosened by their hooves more than once endangered his camera. At long last a small herd, stirred up by the Prince's gamekeepers, came along a rocky ridge opposite to Steckel's hiding place and stopped long enough for him to take a series of pictures with his 100cm cannon. The gamekeepers were delighted and Steckel had to put on a show of pleasure for their sake,

but in actual fact he felt far from confident. Had the camera worked properly? Had there been any mix-up among the plate-holders? He had to curb his impatience until evening, but after developing the plates he could report full success to Prince Hohenlohe.

After a number of blank days, Steckel got the kind of shot he had all the time been dreaming about. A game-keeper notified him of the presence of a female chamois with a kid on a certain cliff, and Steckel decided to try his luck once again. As he climbed higher and higher, he stopped on top of every ridge, carefully searching the rocky wilderness ahead for his quarry. Having discovered the animals, he stalked up to within about sixty metres of them, brought the bulky camera into position and took several pictures as the unsuspecting chamois scrambled up the rock face. They finally settled down on a picturesque crag, and

Douglas English: A harvest mouse photographed in captivity (*Frank W. Lane*)

Steckel put everything on one last throw. Having adjusted the camera, he uttered a piercing whistle; the two chamois jumped to their feet and looked down, standing out beautifully clear against the sky—and in this ideal position they were immortalized on the photographic plate. Steckel returned to the Tatra Mountains in December and became the first to make a photographic study of chamois during the rutting season.

Examples of Steckel's work can also be found in the

Meerwarth and Soffel volumes dealing with birdlife. He may, in fact, have been one of the very first to photograph displaying blackcocks. He was always ready to share his own know-how with others, but felt deeply disgusted when one of his most promising pupils passed around 'authentic nature photographs' of a woodlark tied to the top of a small tree and of young captive birds of prey, gobbling up meat on a tree trunk after having been half-starved.

These, of course, were clear cases of 'nature faking', to use an expression coined by Theodore Roosevelt. There are, however, many animals of which it is very difficult, if not impossible, to obtain satisfactory photographs in a wild state. If they are to be photographed at all it has to be under a certain amount of restraint—or rather control—and there is nothing wrong with this as long as the animals are kept and handled with utmost care and do not find them-

C. W. R. Knight: Sparrow hawk and young. From Knight, *Wild Life in the Tree Tops*

selves forced to behave in unnatural ways. Most of the illustrations of small and more or less nocturnal mammals chosen for reproduction in Meerwarth and Soffel's volumes were from the collection of Douglas English, who had made a speciality of studying and photographing hedgehogs, moles, shrews, harvest mice, voles, mice and rats, pine martens, stone martens, otters, polecats and wild cats amidst carefully imitated 'natural surroundings'. His photographs remained for a long time to come the only really good ones of many species.

Much more recently, photography under 'control' has played an important part in the making of many an excellent animal film which could not have been produced in any other way. This, of course, also applies to Ronald Austing's fantastic high-speed flash exposures of owls catching mice, and to John Dominis' sequence of a leopard chasing and killing a baboon.

Douglas English became the editor of *Wild Life,* a very well produced monthly magazine illustrated entirely with photographs. The first issue appeared in January 1913; unfortunately it ran for two years only, but its pages bear witness to the impressively high standard British nature photography had attained in the years immediately preceding the war. There are articles on mammals by Lionel E. Adams and Douglas English, and on reptiles, amphibians, fish and insects. Birds naturally dominated the scene, one whole issue, for instance, being devoted to studies of the nightjar in various parts of Britain.

Among the many ornithological contributors, besides Farren, King, Lodge, Macpherson and Pike, we notice G. A. Booth, Arthur Brook, B. D. Ferguson, Riley Fortune, J. S. Symonds and Arthur Taylor; G. C. S. Ingram and H. Morrey Salmon, who later teamed up in the production of books and articles, and C. W. R. Knight, a specialist in photographing the birdlife of the treetops, who performed acrobatic feats of great daring to get his camera close to the nests of rooks, merlins, sparrowhawks and herons. The ladies are very well represented by Miss M. G. Best, Miss Maud D. Havilland who made an expedition to the mouth of the River Yenesey in 1914 to study and photograph the birds of the Arctic tundra, Miss Frances Pitt and Miss E. L. Turner, the great authority on the birds of the Norfolk Broads.

Frances Pitt was to have an outstanding career as a writer on natural history subjects. During the thirties she brought together an enormous collection of mainly British wildlife photographs to illustrate *The Romance of Nature,* of which *Country Life* had asked her to be the editor. In its four volumes we meet again several of the photographers whose pictures had appeared in *Wild Life*—Frances Pitt herself, Miss Turner, Miss Best, Oliver Pike, G. C. S. Ingram and

H. Morrey Salmon, Arthur Brook, J. S. Symonds and also C. W. R. Knight, who had meanwhile embarked on a study of eagles that was eventually to take him to the eyrie of a martial hawk eagle on the South African veld. There are numerous contributions—photographs and articles—by Seton Gordon, by that time a leading authority on Scottish wildlife and especially on the golden eagle. Many new names give evidence of the rapidly growing interest in nature photography—J. Armitage, Ralph Chislett, W. E. Higham, Eric Hosking, John Kearton, R. M. Lockley, J. Markham, Lord Percy, Ian M. Thomson and G. K. Yeates, to mention only a few.

Country Life, the publishers of *The Romance of Nature,* have brought out many books that can be considered landmarks in the history of man's effort to explore the world of nature by means of a camera, among them that masterpiece of zoological scholarship and nature photography *Sea*

Miss E. L. Turner: Young bittern photographed on Sutton Broad, Norfolk, in 1911, the first British breeding record since 1886 (*British Trust for Ornithology*)

Terns or Sea Swallows by George and Anne Marples. Attempts to achieve a similar synthesis on the cinema screen resulted in such excellent documentaries as the films on gannets and grey seals, which were made under the scientific supervision of J. (later Sir Julian) Huxley and H. R. Hewer.

As early as 1885, John Carbutt had had the idea of coating celluloid sheets with photographic emulsion and when George Eastman, in 1889, produced strips of high-speed emulsion mounted on strong flexible bands of celluloid, he opened the way for Edison and the brothers Auguste and Louis Lumière to develop Muybridge's Zoopraxiscope into the modern movie-camera. Motion pictures were at first regarded as a mere curiosity, and it took them a long time to progress beyond the peep show and nickelo-

Miss Frances Pitt: Puffin bringing home a good catch on Skomer

deon stage. Their propaganda value was realised during the Spanish-American and Boer Wars, but we know now that a great many of the shots shown to the public were nothing but outright fakes.

It took considerably longer for the immense educational potential of cinematography to be fully appreciated. Here and there somebody may have speculated on what might really be done with this new invention, but movie-cameras were expensive to buy and even more costly to operate, and there probably was little actual experimentation during the first years of the century. Meerwarth and Snell certainly did not touch the subject of movies in their photographic manuals. Cherry Kearton and Oliver Pike may have been among the very first naturalists to take cine pictures of birds.

C. W. R. Knight: Sacred ibis on a South African bird island. From Knight, *Knight in Africa*

Seton Gordon: Golden eagle
watching over the eaglet in
a Scottish eyrie (*Seton
Gordon*)

3 Camera Adventures Across the World

A Swiss big game hunter, Dr Ad. David of Basle, took some early animal photographs in East Africa and very nearly became the victim of a rhinoceros infuriated by this kind of familiarity. As he showed his slides to a photographic society during the second half of 1907, somebody remarked: 'It would be nice to see the animals in motion.' 'That would be cinematography' another person threw in. 'Why not take a cinematographic camera to Africa?' David thought. On the very next day he travelled to Paris and submitted the idea to the director of France's biggest motion-picture company.

Early in December, David was on his way to the Sudan to his favourite hunting grounds on the Dinder River accompanied by a professional cameraman. The expedition lasted five months and the resulting movie gave a very good idea of African travel, camp life and hunting. It contained interesting shots of vultures fighting over carcases and of kites stealing meat from the camp kitchen. The sequences of game animals were not particularly spectacular, mostly taken at a considerable distance and purely in connection with hunting scenes, but the film as a whole was such a success that in 1910 David was asked to take the same cameraman up the White Nile in order to produce a pictorial record of elephant hunting and of the Shilluk, Dinka and Bari peoples.

While David and his cameraman were filming on the banks of the Dinder, Cherry Kearton went up in an airship —which crashed on landing, fortunately without injury to pilot, photographer and camera—in order to shoot the first aerial movies of London, perhaps the first aerial views ever taken with a movie-camera. He, like Dugmore, realised that East Africa would receive considerable publicity through Theodore Roosevelt's expedition, and 1909 found him in Nairobi, taking as a companion James L. Clark who had just been on safari with Dugmore.

Roosevelt, strangely enough, did not add a cinematographer to his party. The photographic work of the expedition was mainly in the hands of his son, Kermit, who did very well, getting excellent stills of a herd of elephants, of black rhino, giraffe, wildebeest, hartebeest, zebra and of the white rhino of what was then known as the Lado Enclave, later the West Nile Province of Uganda. The naturalists accompanying Roosevelt carried cameras, too, and one of

them, J. Alden Loring, photographed a monitor lizard robbing a crocodile's nest. Roosevelt greatly admired the Keartons' work and he gladly gave Cherry permission to take some movie sequences of himself and his porter safari.

Kearton then went on to film the game herds of the Athi plains, the birds of Lake Naivasha and the hippos of the Tana River. He was charged by rhino and spent days stalking a pride of lions, eventually 'shooting' the big cats as they walked past at a distance of about thirty yards. The film was a tremendous success in Europe and the United States, and Cherry Kearton was able to go back to Africa for more movie work.

He first filmed Buffalo Jones—'Last of the Plainsmen'— and his cowboys lassooing a lioness, a rhino, a giraffe and other animals. His next enterprise was, if possible, even more adventurous. In a book about his African expedition, Theodore Roosevelt had given a graphic account of native warriors spearing a lion, and Cherry Kearton was determined to bring this dangerous way of hunting to the cinema screen. He hired fifteen Masai spearmen and took them out into the game country. His cine-camera was a huge box, mounted on a heavy tripod. It had to be cranked by hand, and to move it from one spot to another after it had been set up was a very laborious business. All too often, the battle was over before Kearton could bring his equipment into a favourable position.

Kermit Roosevelt: A white rhino of the northern sub-species in the West-Nile Province of Uganda. From Theodore Roosevelt, *African Game Trails*

71

Once a lion escaped into a dense patch of bush. The Masai threw stones, yelled and howled, but it refused to move. At that moment Kearton's little fox terrier—appropriately named Simba—dashed in and attacked the lion. One of the Masai hurled a spear and scored a hit. He bounded forward to grab the lion's tail, a feat of daring that would give him possession of the animal's mane—but he found Simba already holding on to it and when he tried to chase her away, she bit his hand. The lion was dead, and Kearton had once more failed to get shots of the fight.

A few days later things for once worked out to perfection, and the encounter took place right in front of the camera. Kearton secured a dramatic film which, in the course of the next few years, was seen by millions.

In 1911, Kearton visited India and took movie pictures of wild elephants and of a tiger that was being driven out

Cherry Kearton: Cormorants nesting in a dead tree in Lake Naivasha. From Kearton, *Photographing Wild Life Across the World*

of cover by a gang of noisy beaters. He then went to Borneo, where he found photographic work extremely difficult. The jungles were very dense and saturated with humidity. It rained almost incessantly, and light conditions were atrocious. He nevertheless got the first cine shots of an orang utan in its native habitat and secured an interesting sequence showing a hornbill feeding its female walled up within the nesting cavity.

The following year it was the turn of North America. Moose were filmed in Canada, ospreys on Gardiner's Island, bears and bison in Yellowstone National Park. An accidental meeting with James Barnes, planning a trip to Africa for 1913 and searching for a companion well versed in photographic and cinematographic work, resulted in the Kearton-Barnes expedition which spent a full year in the field and crossed Africa from coast to coast.

From Nairobi, Kearton and Barnes first made a safari to the waterholes of northern Kenya where excellent pictures of reticulated giraffes, Grévy's zebra, beisa, impala and other animals were obtained. There was one place which Cherry Kearton named 'My little Back Room in Noah's Ark', for every kind of animal present in the area came down at some time or other to drink. The base camp was pitched four miles away so as not to disturb these visitors, and Kearton was able to film the most peaceful scenes imaginable.

The two explorers then journeyed through Uganda to the Congo border, photographed crocodiles on the Semliki River and plunged into the depths of the Ituri Forest which they crossed to the Congo River, following as much as possible, though in the opposite direction, the route H. M. Stanley had taken when he went to the rescue of Emin Pasha. Hopes of obtaining pictures of the okapi, discovered only a short time before, failed to materialise, the photographic equipment of the time simply not being suited to stalking elusive game animals in dense tropical forests. It was only in 1930 that Cornelius Bezuidenhout, a South African hunter, succeeded after several weeks of hard work in securing several snapshots of a wild okapi. To get close enough to his quarry he had to camouflage himself with the skin of a giant forest hog.

The First World War saw Cherry Kearton back in Africa. Together with F. C. Selous, the famous sportsman-naturalist, and a number of other hunters, explorers and adventurers, he joined the 25th Battalion of the Royal Fusiliers, also known as Driscoll's Scouts or the Frontiersmen, and went through the adventurous campaign in German East Africa. After four years full of narrow escapes he was finally sent home with a bout of combined malaria and dysentery.

During the twenties, Kearton went to South Africa to film the penguins of Dassen Island to which he devoted a

delightful book, and the white rhinos of Zululand. He also undertook another major expedition to East Africa, producing the movie picture *Tembi*, of which Lutembe, the sacred crocodile of Lake Victoria's Murchison Gulf, was one of the stars. Wherever his travels took him, he turned his lenses not only on big game, but also on the small creatures that came his way—be they tree frogs or chameleons, pintailed wydahs, sand grouse or cormorants, hyraxes, mongooses or jumping hares, praying mantises or butterflies. His camera even explored the secrets of a termite hill.

The last few years before the First World War saw a number of cinematographic expeditions to Africa. Paul Rainey, a wealthy American sportsman, took a movie team to the waterholes of northern Kenya. Carl E. Akeley of the American Museum of Natural History experienced failure in trying to film Nandi tribesmen spearing lions and became so disgusted with his unmanageable cine-camera that he sat down and designed a new and handier one. Carl Hagenbeck, the famous animal dealer, after adding a movie theatre especially for showing nature films to his zoo at Stellingen, induced his East African representative, Christoph Schulz, to take the cinematographer Robert Schumann to the Crater Highlands, where he filmed rhinos, hippos and the wildebeests of Ngorongoro Crater. The ex-elephant hunter Hans Schomburgk, who had meanwhile

Cherry Kearton: The photographer with 'Toto', his famous pet chimpanzee. From Kearton, *Photographing Wild Life Across the World*

Cherry Kearton: Rock hyraxes 'like a family party at a circus' (*Cherry Kearton*)

Fridtjof Nansen: Walrus on an ice floe off Franz Josef Land. From Meerwarth and Soffel, *Lebensbilder*

made a name for himself by bringing back alive the first Liberian pigmy hippos, led a film expedition to the German colony of Togo.

Handier cameras and faster negative material, lightweight film-packs and especially the much wider use that could be made of pictorial records due to the invention of half-tone reproduction, greatly increased the importance of photography in scientific exploration. Fridtjof Nansen had seven cameras on the *Fram,* when she drifted across the Arctic Ocean from 1893 to 1896, and even though he was an accomplished artist, able to make accurate sketches of whatever he saw, he nevertheless carried one of them on his audacious dash towards the Pole with one companion and three sledges. On the long return journey from 86° 36′ to Franz Josef Land he took some excellent snapshots of walrus.

J. B. Tyrrell, the Canadian geologist-explorer, photographed an enormous concentration of barren-ground caribou on 30 July 1893 at Carey Lake. There were, in his words, 'many great bands literally covering the country over wide areas. The valleys and hillsides for miles appeared to be moving masses of caribou. To estimate their numbers would be impossible. They could only be reckoned in acres or square miles'. The snapshots of polar bears taken by the Jackson-Harmsworth expedition to Franz Josef Land may have been the first of their kind, while Johannes

76

Madsen, a Danish naturalist, came back from Greenland with some early pictures of musk oxen.

J. B. Tyrrell: Concentration of barren-ground caribou at Carey Lake, Canada, July 1893 (*Geological Survey of Canada, Ottawa*)

On de Gerlach's *Belgica* expedition of 1898-9—the first to winter in the Antarctic—the medical officer, Dr Frederick A. Cook, also acted as photographer and secured quite a number of pictures of zoological interest. The *Scotia* expedition of 1902 to 1904 to the Weddell Sea sector of the Antarctic under the leadership of William S. Bruce was as much a biological—especially oceanographical—as a geographical enterprise, and the scientific staff brought together a truly splendid series of photographs of Weddell seals, sea leopards, crabeater seals, various species of penguins, blue-eyed shags, sheathbills and petrels. Published in one of Gowan's paperback *Nature Books,* they must have given many people a first glimpse of Antarctic animal life.

While the *Scotia* was exploring the Weddell Sea, discovering Coat's Land in the process, Captain R. F. Scott, using the frozen-in *Discovery* as a base, pioneered the route that was to lead to the South Pole and established the presence of a high, ice-covered Antarctic plateau. Photography was in the hands of one of the naval officers, Lieutenant R. Skelton, and interesting pictures were taken of Adélie penguins and particularly of the emperor penguin rookery at Cape Crozier, of which Skelton was the discoverer; but good and valuable as they were, the photographs of the *Discovery* expedition tended to be over-

shadowed by the superb drawings and paintings produced by Dr Edward Wilson.

When Scott prepared to go south again, he decided to take along a professional photographer who, besides taking stills for the expedition records, would be able to bring its achievements before the public, in the form of a cinematographic film. He chose Herbert G. Ponting who had travelled widely and brought home strikingly beautiful photographs from the Alps, California, Japan, Manchuria, China and India. He was, in fact, one of the most famous outdoor photographers of the time and his work had appeared in leading magazines and periodicals on both sides of the Atlantic. When Scott contacted him, a book of Ponting's, *In Lotus-Land Japan,* was about to be published, and he was also under contract to the Northcliffe Press for a two-year photographic tour of the Empire. Ponting felt greatly drawn to Scott, however, and was so fascinated by his plans that on the spur of the moment he decided to throw up this opportunity and join the Antarctic expedition instead. As far as equipment was concerned, Scott gave his photographer a very free hand, and Ponting finally assembled an outfit 'the like of which', the *British Journal of Photography* said, 'has probably never been brought together'. He had two of the most up-to-date film-cameras, a Newman-Sinclair and a Prestwich, as well as a number of still-cameras,

H. G. Ponting: Photographing sacred 'muggers' (marsh crocodiles) in India (*Popperfoto*)

amongst which he favoured a reflex of his own design. He also took along a Sanger-Shepherd camera with a 5ft extension for photo-micrographic pictures of scientific specimens. Ponting had had no experience whatever in taking movie pictures, but he wholeheartedly began to learn, and soon made himself as much a master of this new craft as he already was of still photography.

In his Antarctic work, Ponting surpassed himself. His movie picture became a model of what an expedition film should be like, while the stills, having triumphantly stood the test of time, are being re-published even today. Scott and Wilson were especially keen that Ponting should produce a photographic record of Antarctic wildlife. Having hitherto photographed animals only very occasionally, he now tackled this part of the programme with characteristic energy and enthusiasm. Cape Evans, where Scott's base camp had been established, was much less suited to zoological studies than South Georgia and the islands of the Weddell Sea sector, but working extremely hard under difficult conditions, Ponting got together a remarkably complete pictorial account of the Weddell seal, the Adélie penguin and the Antarctic skua, even recording some facts which had hitherto been overlooked by the professional naturalists. His stills of skuas stealing penguin eggs, of penguins courting, building their nests and being snowed in by

H. G. Ponting: Weddell seal and pup (*Popperfoto*)

a blizzard, and of seals suckling their pups can be admired in his book *The Great White South*, which achieved a popularity hardly second to Scott's own journal and to Aspley Cherry-Gerrard's *Worst Journey in the World.*

The Australian, Frank Hurley, called Ponting 'the leader of Antarctic photographers' and said of his pictures that they were the acme of photographic perfection. Hurley knew what he was talking about, for he went south a year after Ponting as a member of Sir Douglas Mawson's Australasian expedition to Adélie Land. In 1914 he became the official photographer of Sir Ernest Shackleton's trans-Antarctic expedition which ended in glorious failure, when the *Endurance* was crushed by the pack-ice of the Weddell Sea. Despite shipwreck and incredible hardships, Hurley brought back a wonderful film in which penguins and elephant seals figured prominently—the first movie picture,

H. G. Ponting: The photographer among Adélie penguins (*Popperfoto*)

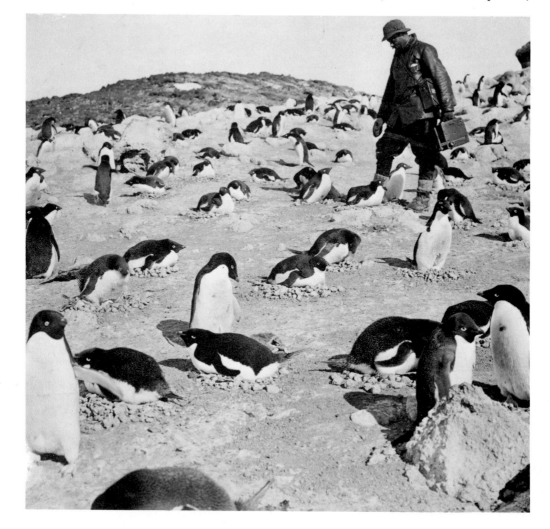

incidentally, which the author of this book was allowed to see as a small boy and one he will never forget.

Ponting and Hurley had a worthy successor in Alfred Saunders, who sailed as a photographer and laboratory technician on Scott's old *Discovery* when she went south in 1925 for a programme of oceanographical research, mainly in connection with the biology and ecology of whales. Saunders later transferred to the Royal Research ship *Discovery II* and spent a great deal of time in the Antarctic right up to 1939. 'It was a hard life,' he wrote in retrospect, 'and a great adventure. Now, more than ten years after, the voice of the frozen south calls me and my camera still.'

Many outstanding men have served in the Imperial Forest Service of India. One of them was F. W. Champion, who obtained a photographic record of jungle wildlife in all its splendour before the wholesale and irresponsible slaughter

H. G. Ponting: Antarctic skua feeding its chick (*Popperfoto*)

of game animals that followed the end of the Second World War. In his book *With a Camera in Tiger-Land,* Champion wrote: 'I began to try to take natural history photographs when I was about 12 years old, my inspiration being the beautiful bird pictures of Richard and Cherry Kearton and the flashlight photographs of the German, Schillings. My first subjects were the familiar tits which used to visit the pieces of fat and coconut placed in our garden by my parents and I came to India in 1913 with the definite ambi-

81

A. Saunders: Bull elephant seals fighting, Livingston Island, South Shetlands (*Frank W. Lane*)

A. Saunders: Wandering albatross on nest on Campbell Island, New Zealand (*Frank W. Lane*)

F. W. Champion: Tiger prowling along a jungle path; it took its own picture by touching a trip-wire (*F. W. Champion*)

F. W. Champion: Flashlight photograph of a leopard with its kill, a cheetal hind. (*F. W. Champion*)

tion of trying to produce photographs of tigers. The War broke out, however, a few months after my arrival in the country, and owing to the interruption caused by a period of active service and the general upheaval after the War, it was not until 1921 that I first obtained definite opportunities at achieving my long-cherished ambition. During 1921, 1922 and 1923 I tried in various ways to obtain these photographs by daylight, but all my efforts proved futile, partly because I still used a rifle occasionally, but mainly owing to the nocturnal habits of tigers. So I finally decided to take up flashlight photography and to give up shooting entirely, the result of this dual decision being that I at last obtained the pictures which I had so long sought for in vain. A fond relative has now suggested to me that a suitable title for this book would be: From Titmouse to Tiger.'

Champion used his flash-camera—an ordinary tropical model quarter-plate Sanderson—with trip-wires, and in this way he caught not only tigers on their nocturnal prowls but also leopards, jungle cats, leopard cats, fishing cats, jackals, ratels, striped hyenas, wild dogs and sloth bears—once even a she-bear carrying two cubs on her back, thus providing definite proof for a story that had been doubted by many.

Hunting by day, often from the back of a well-trained shikar elephant and usually with a quarter-plate Soho (APM) reflex fitted with a 12in Dallmeyer Dallon fixed-focus lens, Champion photographed wild elephants, various

84

species of deer and antelope, goral, palm squirrels, foxes, crocodiles and ghavials, sarus cranes, kingfishers and other birds. On two occasions he was lucky enough to get daylight exposures of tigers.

At about the time that Champion took his first flashlight photographs of tigers, G. M. Dyott, official photographer of the Vernay-Faunthorpe expedition collecting Indian big game specimens for the American Museum of Natural History, got some movie shots of driven tigers and rhinoceroses. Arthur Musselwhite later published a book with dramatic photographs of tiger hunting with shikar elephants, thus leaving a pictorial record of a sport now practically defunct. The only camera-hunter, however, to equal Champion's Indian pioneer work was the Swede, Bengt Berg, at that time already a highly experienced wildlife photographer equipped with the very best cameras obtainable.

Like Frank M. Chapman, Bengt Berg had taken up bird photography in connection with a museum project. Commissioned by Professor Alexander Koenig of Bonn to obtain the materials for a number of habitat groups of northern birds, he went to Lapland and Finnmarken and, besides collecting what was needed, he photographed habitats, nests, eggs and the birds themselves in order to facilitate the setting up of the exhibits, which can still be admired in the Bonn Museum. Having finished this work, Bengt Berg con-

F. W. Champion: A wild Indian elephant—a big, tuskless bull— squirting water over his body
(*F. W. Champion*)

85

tinued his photographic bird studies, using a Bentzin's Reflex and Universal Camera, as well as some cameras constructed to his specifications and fitted with Busch and Zeiss lenses.

In 1916, he published his first book, a volume containing the life histories of a number of rare Scandinavian birds—the black-tailed godwit, the Slavonian grebe, the black tern and the little gull. He went on to study the eagle owl and the sea eagle, the birdlife of Lake Tåkern and the seabirds of the Baltic. Having photographed the European crane at its nest, he decided to follow this species to its winter quarters on the White Nile. Sailing up-river from Khartoum in a dahabiye, he not only obtained stills and movies of enormous concentrations of cranes and other migrants, but also of crocodiles and of marabou storks and vultures gathered around the remains of a hippo killed by native hunters.

His cine-film was so successful that somewhat hazy plans for a longer, better-equipped expedition soon began to take concrete shape. While working at the Bonn Museum, Bengt Berg had seen specimens of the whale-headed stork or Abu Markub, the 'strangest bird on earth' as Professor Koenig, just back from a collecting trip to the Sudan, called it. Would it be possible to get photographs and movies of the Abu Markub, the 'father of the shoe'? Bengt Berg teamed

F. W. Champion: A large gharial (also known as ghavial); the bony excrescence on the tip of the muzzle is characteristic of old males (*F. W. Champion*)

up with a Scottish big game hunter, Major Ross, who was also an excellent artist, and the two of them chartered a steamer that took them to the confluence of the White Nile and the Bahr-el-Ghazal. Among the vast marshes of the Sudd, Bengt Berg filmed the whale-headed stork, and he also got what were then just about the most spectacular movies of African elephants.

To photograph the bearded vulture—the legendary lammergeyer—was the Swedish naturalist's next ambition. To achieve this he went to the Himalayas, this time accompanied by his wife. A balloon basket that had served well on Baltic cliffs was lowered to the overhang under which the eyrie was situated. The photographer got excellent close-ups of the parent birds, but there was a rock corner which usually hid the solitary youngster and around which it seemed impossible to manoeuvre the hide. One day, Mrs Berg decided to have a look at the eyrie and as she was lighter than her husband, the balloon basket could at long last be moved sufficiently for her to peer into the depth of the rock cave and take photographs of the huge lammergeyer feeding its young.

The Bergs were fascinated by India and they again and again returned to the jungle, taking flashlight exposures of tigers, leopards, bears, gaur, water buffalo and other game. There was one Indian animal, however, of which there were

Bengt Berg: Cranes migrating along the White Nile. From Berg, *Mit den Zugvögeln nach Afrika*

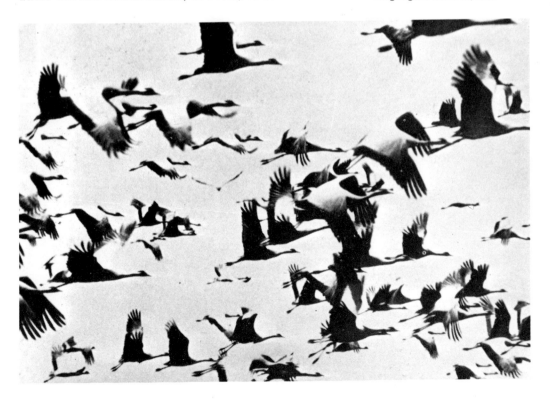

as yet no really satisfactory photographs showing it undisturbed in its native habitat—the one-horned, armour-plated rhinoceros, a species close to extinction, just barely hanging on in a few game reserves. Bengt Berg knew only too well that the authorities felt disinclined to let even the best-intentioned visitor get anywhere near these last survivors, but he nevertheless went to Jaldapara Reserve, guarded by E. O. Shebbeare of the Imperial Forest Service, and the near-miracle happened. Realising that Bengt Berg's pictures would be invaluable as propaganda material in a campaign to secure better protection for the threatened rhinos, Shebbeare allowed him to enter the reserve. The Swedish

Bengt Berg: Abu Markub, 'father of the shoe'—a whale-headed stork photographed in the swampy area known as the Sudd. From Berg, *Abu Markub*

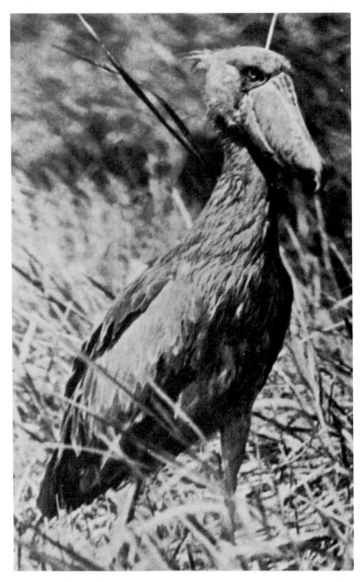

naturalist pitched his camp east of the Torsa River, concentrating his efforts on about 7¾ square miles of jungle, which he found inhabited by 20 to 25 of the last 35 to 40 rhinos of Bengal. After a few weeks he had a unique collection of flashlight photographs of the huge beasts peacefully going about their business in the vastness of their elephant-grass jungle.

Bengt Berg's book on the Indian rhinoceros was published in 1933. Three years later, the first pictures of the Sumatra or two-horned Asiatic rhinoceros in its native habitat were reproduced in the *Journal of the Bombay Natural History Society,* taken at a salt lick in Pahang,

Bengt Berg: Indian rhinoceros among the elephant-grass marshes of the Jaldapara Reserve. From Berg, *Meine Jagd nach dem Einhorn*

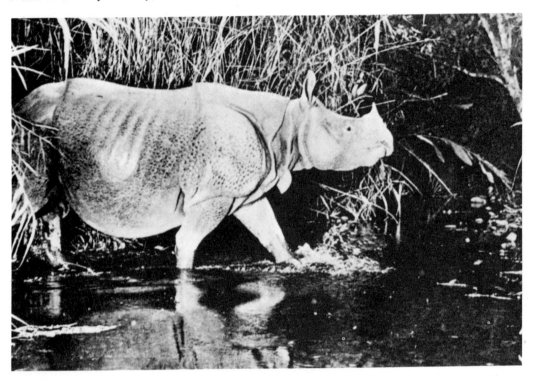

Malaya, by T. Hubback who, at the same place, also secured photographs of Malayan sambhars, seladang and wild elephants. In December 1940 and January 1941, A. Hoogerwerf, the Dutch naturalist and conservationist, obtained the first good series of photographs and movies ever taken of the Javanese rhinoceros at a wallow in the Udjung Kulon Reserve of Java. He also photographed banteng, and sambhar, and took what is probably the only existing snapshot of a wild Javanese tiger.

Interesting photographs of thamin and other deer, elephants, gaur, saing (Burmese banteng) and various small creatures were published in 1933 by E. H. Peacock, the Burma game warden. 'I am not greatly enamoured of flash-

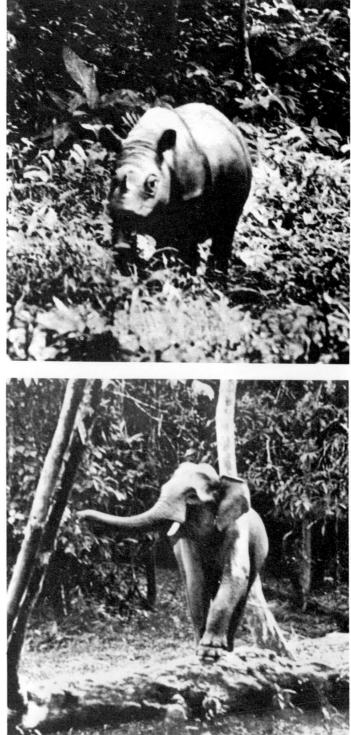

(*right above*) T. R. Hubback: Sumatran rhinoceros visiting a salt lick in Pahang, Malaya. From the *Journal of the Bombay Natural History Society*

(*far right above*) A. Hoogerwerf: Javanese rhinos, photographed in the Udjung Kulon Reserve, Java. (*Dr A. Hoogerwerf*)

(*right below*) T. R. Hubback: Wild Malayan elephant balancing on a fallen tree polished by the feet of many elephants playing the same game; photographed with a 20cm telephoto lens. From the *Journal of the Bombay Natural History Society*

(*far right below*) A. Hoogerwerf: A herd of banteug in the Udjung Kulon Reserve (*Dr A. Hoogerwerf*)

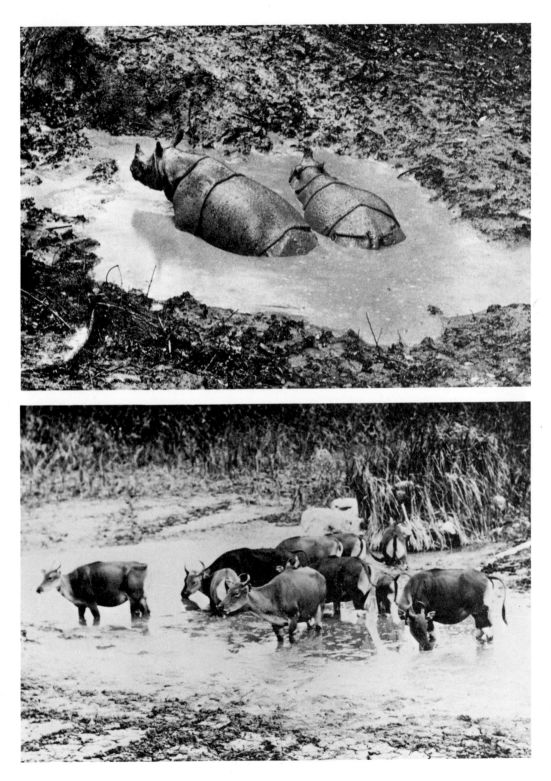

91

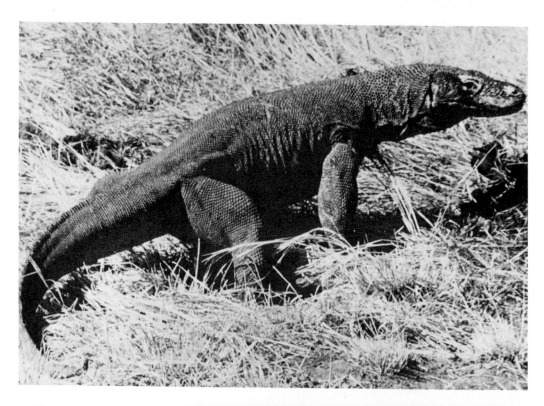

A. Hoogerwerf: Portrait of a
dragon: the giant monitor
lizard of Komodo Island
(*Dr A. Hoogerwerf*)

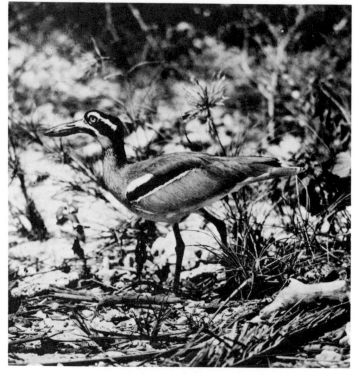

A. Hoogerwerf: Great stone
curlew (*Dr A. Hoogerwerf*)

light,' he wrote, 'but it is the only certain way of obtaining good photos of tigers.' With fairly primitive equipment he succeeded in taking a few pictures of a tigress at a kill.

Superb daylight exposures of tigers have in recent years come from Kanha National Park in India where the striped cats, strictly protected since 1952, display an increasing tendency to move about in broad daylight.

J. B. Shackelford: The wild ass of the Gobi Desert, also known as dziggetai, photographed from a motor car driven at full speed (*The American Museum of Natural History*)

As far as Central Asia is concerned, J. B. Shackelford, the official photographer of the 1922-3 Asiatic expedition of the American Museum of Natural History led by Roy Chapman Andrews, took excellent photographs and movies of the wild asses and gazelles inhabiting the Gobi Desert. Most people going to the Himalayas and Tibet, however, were bent on geographical exploration, mountaineering, trophy hunting or specimen collecting and did not equip themselves for animal photography. Lt-Col Stockley and zoologist Ernst Schaefer were about the only ones to bring back a few pictures of deer, barhel, serow, bear and various species of birds.

It was the game fields of Africa which, during the twenties and thirties, formed the happy hunting grounds of an increasing number of wildlife photographers. Shortly after the First World War, Marius Maxwell, farming in Kenya, began stalking elephants, rhinos, hippos and buffalo, as well as other game animals and birds, with a reflex-camera fitted with an anastigmat lens of 6in or at the most 10in focal length. No believer in big telephoto lenses, he liked to get as close to his subjects as possible.

Maxwell had a keen interest in animal locomotion, and knowing that Muybridge never had had a chance to make a giraffe gallop past his cameras, he became one of the first photographers to snap pictures of African animals from a

Marius Maxwell: A troop of hippopotami on the banks of the Uaso Nyiro. From Maxwell, *Stalking Big Game with a Camera in Equatorial Africa*

motor car. Chasing at full speed over the veld in a Ford and using an Ensign Popular Reflex fitted with what was then one of the fastest British lenses, a Ross 'Xpress' f/4.5 with a 6in focus, he obtained a series of action photographs from which he could study the giraffe's gait. Maxwell also used his camera for behavioural studies—recording, for instance, the way elephants expressed their moods through the positioning of their ears. He published his photographs and observations in a very fine volume—*Stalking Big Game with a Camera in Equatorial Africa*—with a valuable appendix summing up what was then known about the African elephant.

It must be stressed that African camera hunting on foot was not without its very real dangers, particularly in areas open to shooting, but also in most of the reserves, which in those early days simply could not be patrolled with the desired degree of efficiency. Even though the great majority of big game animals preferred to move off on scenting human beings, there were the occasions when the cameraman's life depended on a quick and well-placed shot. Schillings, Dugmore, David, Cherry Kearton—all had their narrow escapes.

Maxwell usually managed to stop a charging rhino by shouting at it, but one animal came rushing on blindly and had to be shot by his companion. On a safari to the Lorian Swamps of northern Kenya, accompanied by white hunter

J. M. Barnes, Maxwell got photographs of a quite exceptionally dramatic quality when a group of seven elephants, apparently instigated by a nervous cow, began to advance in V-formation on the two men. Using pack-film, Maxwell was able to snap off pictures in quick succession. He had posed his reflex on a tripod without screwing it down so that he could retreat with it in case of need, leaving the tripod to take its chance. For the moment, however, he did not think of running away. 'The idea of recording the fascinating and impressive sight', he later wrote, 'was so tempting that I was unconsciously disposed to pay no heed to the possible consequences.' The cow which had started the trouble suddenly rushed forward in line with the foremost animals on the branches of the V, one of them a big bull. Maxwell exposed a photograph when the elephants were a dozen paces away. Barnes shot at the cow and Maxwell himself grabbed his 0.600 bore and gave the big bull both barrels. The animal collapsed, and the cow subsided a few seconds later. To avoid further bloodshed, the two men hastily moved back a dozen paces, and Maxwell took two more pictures of the survivors aimlessly crowding around the carcasses. The big bull's head skin, skull and tusks were presented to the British Museum.

In 1920, a Swedish film company sent one of their best cameramen, Oskar Olson, to East Africa. He had spectacular success at the waterholes of northern Kenya, where

Marius Maxwell: A snapshot taken from a car in order to illustrate the various phases of the giraffe's gait. From Maxwell, *Stalking Big Game with a Camera in Equatorial Africa*

Cherry Kearton and Paul Rainey had filmed before the War. To get lion pictures, he made a safari to the Mara River and sat up over kills night after night on a tree platform, hoping the big cats might one morning linger at their meal until after sunrise. They mostly disappeared long before the light was strong enough for photography, but finally Olson was lucky and got the shots he was after. He then joined the Swedish zoological expedition to the Virunga volcanoes and the Ituri Forest led by Prince William, filmed the game herds and hippos of the Rutshuru plains and the birds of Lake Edward, but failed to get pictures of live mountain gorillas. Photographs taken out of Olson's films were published with a text by Prince William of Sweden.

Shortly after the Swedish expedition had left the volcanoes, Carl E. Akeley visited the area to collect materials for a gorilla group in the American Museum of Natural History. One memorable day on the slopes of Mount Mikeno, he got so close to some gorillas that he was able to film them with his Akeley Panoramic Camera. When he reached camp that night, his mind flew back to the days when he had vainly tried to obtain movies of Nandi tribesmen spearing lions. This, of course, had set him off to work on a more manageable type of camera. 'Few things have given me greater satisfaction', he wrote, 'than the realisation that the failure of 1910 had led directly to the success of 1921.'

Marius Maxwell: Bull elephant photographed at a distance of approximately eight yards with a quarter-plate hand-camera fitted with a 6in Xpress lens, in the Mara River area, Kenya. From Maxwell, *Stalking Big Game with a Camera in Equatorial Africa*

Dr E. Gromier, now a member of the French Colonial Medical Service and equipped with better cameras than he had in East Africa before the War, became the first to photograph lowland gorillas in their habitat. He also secured pictures of the West African race of that very elusive antelope, the bongo. His books did much to introduce camera hunting in the French-speaking countries.

An Austrian sportsman and wildlife photographer, H. A. Bernatzik, visited the game fields of the Dinder River in 1925 and took very fine pictures of game animals and birds with a 9 x 12 Voigtländer Reflex Camera. He used Agfa-Chromo-Isolar plates in preference to pack-films which, he thought, would not have withstood the heat of the Sudan, even though soldered into tin cassettes.

With expedition films having become popular through Ponting and Hurley, Angus Buchanan—crossing the Sahara

Carl E. Akeley with gorilla deathmask. From Akeley, *Lions, Gorillas and Their Neighbours*

in 1922 by camel caravan in order to collect specimens for the British and Tring Museums—took along T. A. Glover, a very experienced cinematographer. The resulting movie was one of the best ever taken in that part of the world, perhaps the only one showing desert travel very much as it had been at the time of the great nineteenth-century explorers, such as Denham and Clapperton, Barth, Nachtigal and Duveyrier. Two years later, Glover joined Major C. Court Treatt and his wife Stella on the first Cape

to Cairo journey by motor car. It was an epic adventure, a constant struggle against overwhelming odds, but time was nevertheless taken off in southern Tanganyika to get the animal pictures without which a film about African travel would not have been complete. The Court Treatts must have learned a lot from Glover, for two years later they went to the Southern Sudan, using a Morris lorry facetiously named 'Star of the Desert', and filmed *Stampede,* a movie that cleverly combined game shots with scenes of native life.

The old-time porter safari was rapidly giving way to the motor car. Expeditions became much more mobile and were able to reach with comparative ease distant regions which not so long ago had been largely inaccessible. Control over game reserves was tightened up and photographers could operate much more safely within their boundaries.

E. Gromier: West African forest elephant trying to get the photographer's scent. From *Le Grand Livre de la Faune Africaine et de sa Chasse*

E. Gromier: Bull bongo crossing the Aina River, Cameroon. From Gromier, *La Vie des Animaux Sauvages du Cameroun*

H. A. Bernatzik: Soemmering's gazelle drinking in the bed of the Dinder River. From Bernatzik, *Typen und Tiere im Sudan*

Working mostly from cars, they ran less danger of having to kill an attacking rhino, elephant or buffalo. As there never had been any shooting from motor cars, many animals showed little or no fear of the rattling monsters. In 1928, on her second visit to East Africa, Vivienne de Watteville spent most of one day at Selengai stalking a giraffe on foot without ever getting close enough for a cine shot. Describing a subsequent trip from Selengai to Kajiado by lorry, she writes: 'On the way I saw silhouetted against the sky what looked like an anthill with a post sticking out of it. The nearer we drew, the more I was puzzled, till I saw that it was a giraffe lying down. We drove up close to him before he roused himself to the effort of getting up, and as I had been told on good authority that giraffes never lie down I thought that there must be something very wrong with him. But a little farther on I saw a herd of fifteen, and three of them were also lying down. So long as we kept inside the lorry they did not mind how near we came, in fact, Karna, always ready to oblige, left the track altogether and drove the lorry, perilously rocking over the bumpy ground, into the very midst of them. It was certainly the very nearest I was ever likely to come to patting a giraffe; and I was forced to the sad conclusion that although there was no romance in photographing wild animals from a car, there is no comparison in the results. However long I stalked them on foot, and however hard I worked, I should

Marcuswell Maxwell: Serengeti lions settling down to their digestive siesta— fifteen yards from the photographer's car (*The Times*)

101

never be able to come so near them. Cars roused only their curiosity and, as yet, were unconnected in their minds with danger.'

Lions, in particular, proved to be amazingly tolerant of motor cars. In reserves, where they had not been hunted for a good number of years, they also began to take on increasingly diurnal habits. Colonel Marcuswell Maxwell, a graduate of engineering of Sydney University who had come to East Africa in 1919, went to the Serengeti plains during the late twenties and without any previous experience in stalking big game brought back a series of lion photographs which amazed camera-hunters the world over. They showed prides in bright sunlight, at a kill, resting in the shade, even a lioness scrambling around among the low branches of a tree—the kind of pictures, in fact, which present-day safari tourists expect to get, and usually do! Maxwell reported that he drove his car to within fifteen yards of the pride under the tree and had to back in order to include the whole group. The lions at the kill let themselves be snapped from a distance of five yards.

Having been so successful with lions, Marcuswell Maxwell made two safaris after elephants, this time accompanied by an experienced hunter. The first one failed owing to bad light. On the second, close to where the Namanga River Hotel now stands, he saw a herd going

Marcuswell Maxwell: Elephants drinking at a waterhole near Namanga, Kenya (*The Times*)

through thick bush towards a waterhole. Running fast, he arrived there first, prepared his camera and watched the approaching animals. He got sensational shots of the herd drinking, but after a while the wind turned and the pachyderms moved off. The next day, Maxwell had equal luck with some bulls. He also took excellent pictures of plains game, rhino and of buffalo on Oldonyo Sabuk.

Following almost exactly in Maxwell's footsteps on our first camera safari in 1949, my wife and I found the lions of the Serengeti just as Maxwell had described them. Stalking elephants near Namanga I, too, experienced a sudden change of wind. The animals, however, did not move off—they charged in the midst of a huge cloud of dust. Unarmed, all I could do was run for my life. I finally stumbled in the tough, tangled grass and fell flat on my face. Twisting round, I saw a cow tearing down on me with ears spread out, looking like a ship under full sail. She came to within about twelve or thirteen yards, stopped, hesitated for a moment, swung round and went away.

Some of my readers may remember the wonderful films taken during the twenties and thirties by Martin and Osa Johnson. As a youngster, Martin, keen on seeing the world, had answered an advertisement put in by Jack London, the writer, who wanted a cook for the *Snark,* the boat he was outfitting for a cruise to the South Seas. Johnson's

Marcuswell Maxwell: Buffalo herd in thick cover on Oldonyo Sabuk, a mountain not far from Nairobi (*The Times*)

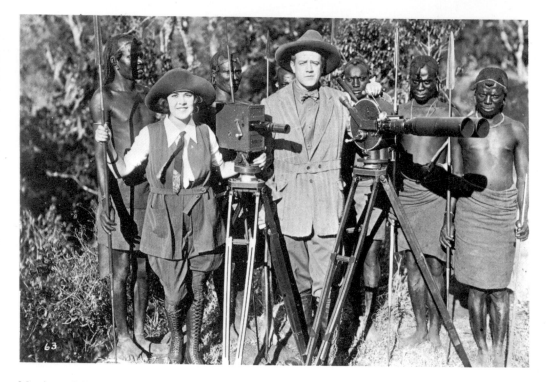

Martin and Osa Johnson:
The photographers with an
old-time cine-camera and—
on Martin Johnson's left—
an Akeley Panoramic Camera
(*The American Museum of
Natural History*)

curriculum vitae, as one biographer put it, did not include
any culinary experience, and as a chef he turned out a sad
disappointment. He had, however, a natural aptitude for
photographic work, was made the expedition's cameraman
and returned to the States with a remarkable collection of
slides. He married Osa Leighty and went on tour with an
illustrated travelogue, his young wife creating the appro-
priate South Sea atmosphere by singing a few Hawaiian
tunes. By 1912, the Johnsons had saved $4000 and they
mounted an expedition to the Solomon Islands and the
New Hebrides. Their movie of headhunters and cannibals
went down extremely well and brought in sufficient money
to allow for a second and better equipped expedition to
the New Hebrides, which resulted in a very noteworthy
film on the natives of Malekula and Espirito-Santo.

There followed a disappointing expedition to Borneo,
where the Johnsons experienced the same constant rains
which, a few years earlier, had frustrated Cherry Kearton.
It was after a meeting with Carl Akeley at the American
Museum of Natural History that they decided to turn their
attention to East Africa. They made a safari to Marsabit
in northern Kenya and were so successful in their filming
of elephants and other game that their next expedition was
jointly sponsored by George Eastman and the American
Museum. They had a fleet of Willys Knight cars at their
disposal, and were mobile enough to establish a base camp

on far-away Mount Marsabit, overlooking a crater lake which they named 'Lake Paradise'. They filmed and photographed a variety of animals and took flashlight pictures of leopards and other nocturnal prowlers. Together with Akeley, the Johnsons went to northern Tanganyika in order to get acquainted with the easily approachable and amazingly diurnal Serengeti lions. After a short visit to the States, they returned to the Serengeti for more lion footage, to be used in their film *Simba*.

In 1930 the Johnsons embarked on an expedition to Uganda and the Congo to film hippo and crocodiles below the Murchison Falls and gorilla among the Virunga volcanoes and on the mountains west of the Central African Rift Valley. They brought two amphibious planes to East Africa in 1933 and later took one of them to Borneo, where an earlier venture had brought little but failure. This time, with vastly superior equipment, they won the battle against rain and humidity and produced a film showing, among many other creatures, orang utans and proboscis monkeys.

Martin Johnson died on 13 January 1937 after the airliner he and his wife were travelling in crashed near San Francisco. Osa survived the accident and devoted the rest of her life to writing and to the production of several more films. She died in January 1953.

The aerial pictures of game taken by the Johnsons were

Martin and Osa Johnson: Zebra and wildebeest at an East African waterhole (*The American Museum of Natural History*)

105

Walter Mittelholzer:
Elephants crossing the Nile
(*Photoswissair*)

not the first of their kind. In 1929, while they were busy
filming lions, the Baron Louis Rothschild of Vienna char-
tered an aircraft to take himself and some friends to a
hunting camp on the Serengeti plains. The plane was
piloted by the Swiss airman-photographer Walter Mittel-
holzer, who had performed one of the earliest Cairo to
the Cape flights, besides having explored Spitzbergen and
Persia from the air. On his second visit to Africa, he not
only flew over Kilimanjaro and Mount Kenya, but also
took breathtaking aerial movies and stills of the huge
Serengeti game herds and of elephants along the Nile.
Mittelholzer's pictures may have induced a German film
company to take similar shots for a feature film dealing
with the search for an airwoman lost in the African bush.
The plane in which the cameras for aerial photography
were mounted was piloted by Ernst Udet, the First World
War ace who had become famous for his incredibly daring
low-flying aerobatics. He often flew only a few feet above the
backs of stampeding zebra and wildebeest, and on one occa-
sion a lioness jumping up at the bushhopping plane and tore
a hole in one wing. Photographs of this incident appeared
in illustrated magazines and in a book, but I must admit
that for a long time I found it difficult to regard the story
as anything but a fantasy hatched for propaganda purposes.
One day, however, I met a South African who had accom-
panied the film expedition in question as professional

106

hunter, and he assured me that everything had happened exactly as described.

The Serengeti lions were now well established as film stars, but they soon received serious competition from their South African cousins. When Hans Schomburgk and cameraman Paul Lieberenz visited the area, which had only recently changed its status from Sabi Game Reserve to Kruger National Park, they found the big cats still very shy, for they had been hunted for a good many years in order to give the ungulate populations a chance to recover from the hammering they had taken during the Boer War. However the Kruger lions tamed down very rapidly and in 1936 a South African wildlife photographer, Bertram Jeary, was able to publish a splendidly illustrated account of their lives and habits. At about the same time Herbert Lang, the American naturalist, produced a very fine album devoted to the game animals of all the South African game sanctuaries.

Even though the Sabi Game Reserve originated at the time of the old Transvaal Republic, before the Boer War, it was not the first African area to be gazetted as a National Park. This distinction goes to the Albert National Park of the eastern Congo, created at the instigation of Carl Akeley. After the cessation of all hunting, the game herds of the Rutshuru-Ruindi plains, which had already been photographed by Alexander Barnes, Oskar Olson and Vivienne de Watteville, soon became very tame and remarkable pictures were taken there before the Second World War by one of the game wardens, Commandant E. Hubert, and by Léon Lippens, the Belgian naturalist.

The movies and photographs coming out of Africa during the twenties and thirties greatly served the cause of conservation, for more and more people came to realise that live animals were so much more interesting than dead ones.

4 From Alaska and Lapland to the Amazon and Patagonia

In North America there was at one time a lot of talk of exterminating the brown bears and grizzlies of Alaska, which the supporters of the idea described as voracious killers of the worst kind. John M. Holzworth, a sportsman who had spent several years doing fieldwork on the mountain sheep of British Columbia, devoted three strenuous expeditions to the filming of bears in order to give the public a better understanding of these much maligned animals. The book in which he described his experiences still rates as a highly valuable monograph on the Alaskan bears, besides containing interesting information on caribou, Dall sheep and mountain goats. Holzworth has given an interesting summary of the changes hunting with a movie-camera underwent in his time. 'Until several years ago,' he wrote, 'it was necessary to pack a heavy crank-driven machine with an equally cumbersome tripod; naturally progress in taking good pictures was slow. For several years I used an Akeley camera. It was an excellent camera and with its special panoramic device was especially adapted for taking pictures of wildlife. But with the extra lens and extra film and tripod it made a back-breaking load of close to fifty pounds. Several years ago, the first automatic camera, the little De Brie was placed on the market. It was driven by a spring but used only fifteen feet of film, which was much too little for practical use. Finally the Bell and Howell Company, which for years had built the greater part of professional studio cameras, developed the two cameras known as the Filmo and Eyemo; each of these is automatically driven and takes a hundred feet of film to a single loading.' It was the Eyemo, using standard 35mm film but nevertheless weighing a mere seven pounds, which Holzworth mostly used in taking his movie sequences of bears and other game. His double appeal—pictorial and written—did not go unheeded and the big bears of Alaska are still with us.

Conservation was also very much the theme of the book *Wilderness Wanderers* in which Wendell and Lucie Chapman gave an account of their observations and adventures while photographing animals, large and small, among the mountains of Colorado, Wyoming, Montana and Canada. Their pictures were of such a high standard that they were accepted for reproduction in the *National Geographic Magazine*. A few years later the Chapmans were able to

submit an article to the *Geographic* on Rocky Mountain game illustrated with colour photographs taken on the newly developed Ektachrome film.

In 1938, Professor A. Allen began an Ektachrome survey of North American birds, sponsored by the National Geographic Society which has done so much to further nature photography in all its different branches. Allen's many contributions to the *Geographic* were assembled in 1951 in that very beautiful volume *Stalking Birds with a Color Camera,* which may be regarded as the distinguished ornithologist's photographic magnum opus.

The twenties and thirties were great times for nature photography in continental Europe. The German master-photographer, Walter Hege, and his pupils turned away from Greek ruins and Gothic cathedrals to filming ospreys, sea eagles, peregrines and other birds of prey. The seabirds of the Friesian Islands drew the attention of several photographers, with W. Schack of Frankfurt—who later became famous for his South African wildlife pictures—taking superb action studies of gulls which were used to illustrate a book on the aerodynamics of bird flight. G. Hoffmann photographed cranes, marsh harriers, sea eagles, crested grebes and many other birds around a north German lake, while Martin Kakies stalked the elk of Eastern Prussia, producing a book that went through several editions within a few years.

Another bestseller from Eastern Prussia was Walter von Sanden's pictorial account of the birds inhabiting Lake Guja. Horst Siewert collected observations and photographs for a book on storks, white and black. Stig Wesslén, a Swedish forester, devoted himself to the portrayal of bears, golden eagles, ospreys, eagle owls, blackcock and capercaillies, as well as the Lapps and their herds of reindeer. H. A. Bernatzik of Vienna photographed seabirds in Lapland, spoonbills on the Neusiedlersee, pelicans on Albanian Lake Malik and herons and egrets in the Danube delta. His countryman, Dr Hans Francke, used his camera to spy on that intriguing little bird, the penduline tit. In Switzerland, where H. Noll had published a very thorough and photographically well documented study of birdlife in the Linth marshes in 1924, B. Schocher began to take photographs of mountain animals which he eventually used to illustrate a general volume on Alpine wildlife, as well as a delightful monograph on the marmot. Working in the Bavarian Alps and in Slovenia, Count Franz Zedtwitz obtained the material for a similar book on the chamois.

Practically nothing has so far been said of South and Central America, and it must be admitted that this part of the world has for a long time been somewhat neglected by wildlife photographers. William Beebe, that great and very versatile naturalist, carried a camera on the ornithological

W. Schack: Herring gulls at
play. From Schack, Leege
and Focke, *Wunder des
Mövenfluges*

Horst Siewert: Black stork at
nest. From Horst Siewert,
Störche

H. A. Bernatzik: Home life
of the White Pelican, Lake
Malik, Albania. From
Bernatzik, *Vogelparadies*

expeditions to Mexico, Venezuela and Guiana which he
undertook between 1903 and 1909, and he turned it on all
the living things that would pose for him. He certainly was
the first to photograph the hoatzin, the young of which have
wings reminiscent of the archaeopteryx with the first and
second digits carrying large, movable claws for climbing
around among the bushes fringing rivers. One of Beebe's
photographs shows no less than eleven hoatzins in one tree.

Beebe later made great use of photography at the New
York Zoological Society's research station on the Mazaruni
River in British Guiana where, besides devoting himself to
many other projects, he continued his study of hoatzins,
and also on his expeditions to the Galapagos Islands and the
Pacific coast of Mexico.

In 1924, the Institute for Research in Tropical America
established a laboratory on Barro Colorado, an island
situated in Gatun Lake which had originated through the
building of the Panama Canal. It was there that Frank M.
Chapman, one of the fathers of American nature photo-
graphy, found many new subjects for his camera. He not
only snapped coatis, capucin monkeys and howler monkeys
jumping fabulous distances from tree to tree, but also
worked with flashlight and trip-wire along the narrow
jungle tracks and secured excellent night pictures of
agoutis, tapirs and peccaries, of pumas and of beautifully
marked ocelots.

One of Chapman's museum colleagues, Robert Cushman Murphy, took many photographs of seabirds and sea lions while investigating the Peruvian guano islands.

The animal life of the Amazon forest was well filmed in 1926 by August Brückner, the cameraman of an expedition sent out by UFA, the German film company. I saw this movie—*Primeval World of the Forest*—as a schoolboy and can distinctly remember its fascinating sequences of

Frank M. Chapman: Ocelots photographed on their nightly prowls along jungle tracks were usually caught with their leading foot ten inches off the ground—as if they had sensed the trip-wire in the dark and tried to clear it; Barro Colorado Island, Panama Canal Zone (*The American Museum of Natural History*)

sloths, anteaters and tapirs, of hummingbirds, leaf-cutting ants and voracious piranhas turning a capybara carcase into a skeleton within a few moments. Having formed his own company, Brückner returned to the Amazon in 1929, took more shots of forest life and went up the Jacarana River to film the unspoilt Ticuna Indians. Falling seriously ill, he was rushed back to civilisation by his companions but died shortly after entering Para hospital.

Embarking upon the zoological exploration of the Gran Chaco, the Argentine pampas and Patagonia, Professor Hans Krieg of Munich soon realised that it was absolutely essential to have a movie record of his investigations. On his third expedition, in 1937, he therefore took along one of his assistants, Eugen Schuhmacher, as cinematographer, arming him with a Bell and Howell Eyemo. Schuhmacher threw himself into the job with enthusiasm, filming lizards, horned frogs and giant toads, snakes, caimans, birds, monkeys and armadillos. The reports on the footage sent to the processing plant in Germany became more and more encouraging but then, one unlucky day, the spring broke, and the Eyemo had to be sent to Chicago for repairs. When it was in working order again, the expedition had long since returned to Europe.

Accompanying Professor Krieg on his fourth expedition five years later, Schuhmacher saw to it that his equipment included a second Eyemo. He started off with the sea lions

August Brückner/UFA:
Portrait of a sloth. From
Heye, *Filmjagd auf Kolibris
und Faultiere*

August Brückner/UFA: The
UFA expedition of 1926 at
work in the Amazon Jungle.
From Heye, *Filmjagd auf
Kolibris und Faultiere*

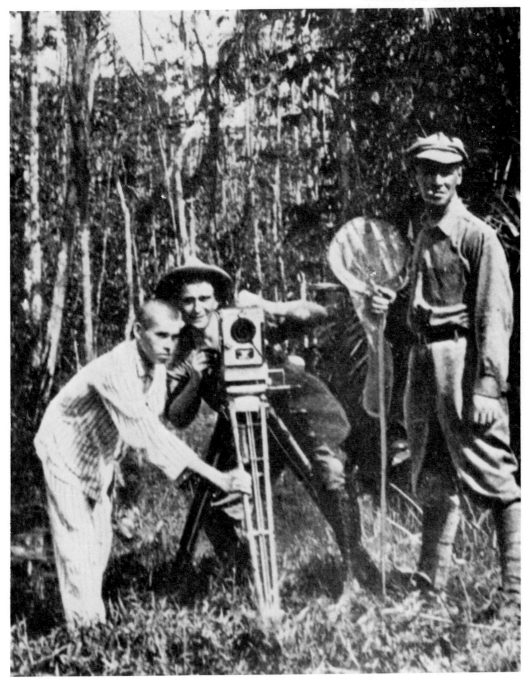

of the Isla de Lobbo on the coast of Uruguay and then went on to film condors in Patagonia. 'From Patagonia we turned north,' he later wrote, 'travelling many hundreds of kilometres. The small film camera purred ceaselessly and its mechanism never gave the slightest trouble. Its sister remained almost inactive during the trip, packed away safely in its case. It was only used when it became necessary to work simultaneously with two focal lengths. Tapirs, peccaries, coatis, anteaters and monkeys, parrots, toucans, wildfowl and owls, swamp turkeys, snake birds and kingfishers, song birds, woodpeckers and hummingbirds, lizards and snakes of all kinds and sizes walked, flew, hopped and

Eugen Schuhmacher: A little anteater or tamandua tearing apart a tree termites' nest. (*E. Schuhmacher, München*)

slithered past my viewfinder. Some a considerable distance away, others almost frighteningly near. Their manifold shapes and motions brought variety to the movie picture that ran under the title: *South America—Garden of Animals.*

Schuhmacher became so interested in this work that he threw up his job at the Zoological Institute of Munich in order to devote his life to animal photography. After the Second World War he became one of the most renowned producers of nature films and, shortly before his death in 1973, the Royal Geographical Society honoured him with the award of its Cherry Kearton Medal.

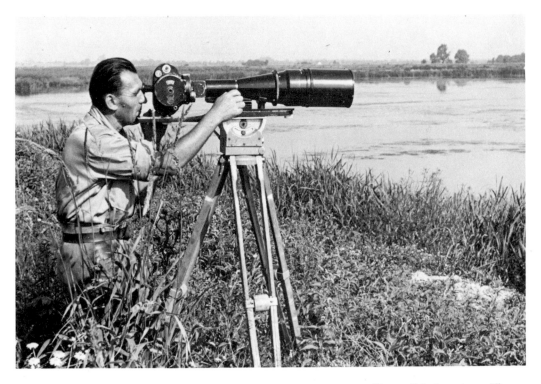

Eugen Schuhmacher: The photographer with his Eyemo Camera (*E. Schuhmacher, München*)

5 The Coming of the Miniature Camera, Colour Film and High-speed Flash

The Eyemo camera was a far cry from the heavy, hand-cranked boxes used by the early pioneers of wildlife films. A change of equal significance came about with the appearance of the miniature still-camera in the form of the Leica, designed in 1913 and put on the market in 1925. I can well remember the stir it caused among photographers, amateur and professional. My father bought one in 1928 when I was fifteen, but soon decided that he had not been born to be a photographer. The camera was handed over to me and I immediately went off to a place where there were great numbers of wall lizards. I still treasure the first zoological picture I ever took. From lizards I went on to butterflies and, when a 135mm lens had been obtained, to birds, chamois, ibex and marmots. I have never used another type of camera, and with lenses of increasing focal length the Leica, in its successive models, has given me faithful service in many parts of Europe and during almost thirty years of African travel and adventure.

Most animal photographers only took to the miniature camera with considerable reluctance, fearing loss of definition through the enlargement of 24×36mm negatives. Some never used it at all, especially those generally working from a hide or with animals under a certain amount of control. Others, however, soon realised that for stalking ibex on Alpine cliffs or buffalo in the African bush there was nothing better. With finer-grained negative material and excellent colour films becoming available, its popularity rose and it was finally adopted by many who had at first been highly critical of it.

In 1936, magnesium flash powder, invented in 1888 by A. Miethe and used by Shiras, Schillings, Dugmore and so many others, was replaced by the flashbulb, and this enabled Eric Hosking to take his wonderful pictures of owls. At that time, however, Professor Harold E. Edgerton of the Massachusetts Institute of Technology had for several years already been working on a high-speed flash apparatus that was to allow exposures of up to 1/100,000 of a second. Series of photographs appeared in various periodicals showing a glass plate shattering under the impact of a bullet, a drop of liquid falling into a cup, a glass being smashed to splinters on the floor. When a portable high-speed flash set giving exposures of 1/5,000 of a second was put on the market in 1945, Eric Hosking bought it at once

and took the pictures which were to appear in his book *Birds in Action*.

In the United States, Donald R. Griffin photographed bats in flight, while Ernest P. Walker and E. L. Wisherd photographed flying squirrels. Arthur A. Allen used high-speed flash equipment in 1947 applying, as he put it, 'new light on the old problems of bird photography'. During the same year the *National Geographic Magazine* published superb high-speed flash pictures of hummingbirds, taken by Harold E. Edgerton himself.

Wildlife photography had come a very long way since James Chapman went ashore in Walfish Bay with his two cumbersome yet fragile cameras.

Bibliographical Notes

Adams, Lionel, Contributions to *Wild Life*

Akeley, Carl E., *In Brightest Africa* (1924); with Mary L. Jobe Akeley: *Adventures in the African Jungle* (1930); *Lions, Gorillas and their Neighbours* (1932). Contributor to *Natural History*. Biography: Mary L. Jobe Akeley: *The Wilderness lives again; Carl Akeley and the Great Adventure* (1940)

Allen, Arthur A., *The Book of Bird Life* (1930); *Stalking Birds with a Color Camera* (1951); Contributor to *National Geographic*

Allen, Francis L., 'Early Wildlife Photographers' (*Country Life*, 2 Jan. 1937)

Andrews, R. C., 'Living Animals of the Gobi Desert' (*Natural History*, No. 2, 1924). *On the Track of Ancient Man:* 'A Narrative of the Field Work of the Central Asiatic Expedition' (1926; photographs mainly by J. B. Shackelford).

Anschütz, Ottomar, Photographs reproduced in Wurm (1897), Zell, *Riesen der Tierwelt* (1910) and other books

Armitage, J., Contributor to *Romance of Nature*

Austing, R., *I went to the Woods* (1963)

Aymar, Gordon, *Bird Flight* (1936)

Barnes, Alexander T., *The Wonderland of Eastern Congo* (1922)

Barnes, James, with Cherry Kearton: *Through Central Africa from East to West* (1915)

Barrett, Charles L., *In Australian Wilds* (1919); *Koonwarra* (1939); *An Australian Animal Book* (1943)

Bates, R. S. P., *Bird-Life in India* (1930); with E. H. N. Lowther: *Breeding Birds of Kashmir* (1952)

Beaton, Cecil, *British Photographers* (1944)

Beebe, C. William, *Two Bird Lovers in Mexico* (1905); *Galapagos, World's End* (1924); *The Arcturus Adventure* (1926); *Zaca Venture* (1939); *The Book of Bays* (1942); *High Jungle* (1950); with Mary Blair Beebe: *Our Search for a Wilderness* (1910); with G. I. Hartley and P. G. Howes: *Tropical Wild Life in British Guiana* (1917); Contributor to *National Geographic, Animal Kingdom*

Beetham, Bentley, *The Home Life of the Spoonbill, the Stork and some Herons* (—); *Among our Banished Birds* (1927)

Behr, M., Photographs published in *Lebensbilder* and in Hinze: *Biber in Deutschland* (1937)

Belgica Expedition, See F. A. Cook

Berg, Bengt, *Sälsynta Faglar* (1916); *Mit den Zugvögeln nach Afrika* (1925); *Abu Markub* (1926); *Mein Freund, der Regenpfeifer* (1927); *Tookern* (1928); *Die letzten Adler* (1928); *Die seltsame Insel* (1930); *Der Lämmergeier im Himalaya* (1931); *Meine Jagd nach dem Einhorn* (1933); *Tiger und Mensch* (1934); *Verlorenes Paradies* (1937); *Augen in der Nacht* (1952);

Meine Abenteuer unter Tieren (1955)

Berger, A., *In Afrikas Wildkammern* (1910)

Bernatzik, H. A., *Typen und Tiere im Sudan* (1927); *Vogelparadies* (1947)

Best, M. G., Contributor to *Wild Life, Romance of Nature*

Bezuidenhout, Cornelius, Photographs of Okapi, published in *Illustrated London News, Kosmos* and other periodicals

Bohlman, H. T., *See* W. L. Finley

Booth, G. A., Contributor to *Wild Life*

Brook, Arthur, Contributor to *Wild Life; Romance of Nature*

Bruce, William S., *See Scotia* Expedition

Brückner, August, First Expedition *see* Heye (1929); a short account of second expedition in Eichorn (1952)

Buchanan, Angus, *Sahara* (1926; photographs by T. A. Glover)

Buxton, E. N., *Two African Trips* (1902)

Challenger Expedition, Thomson, Sir Wyville, *Voyage of the Challenger; The Atlantic* (1877); Mosley, H. M. *Notes by a Naturalist made during the Voyage of the 'Challenger'* (1880); Linklater, E., *The Voyage of the 'Challenger'* (1972)

Champion, F. W., *With a Camera in Tigerland* (1927); *The Jungle in Sunlight and Shadow* (1933). Photographs published in many books and periodicals

Chance, Edgar, *The Truth about the Cuckoo* (1940; Many photographs taken from Oliver G. Pike's films)

Chapman, Frank M., *Bird Studies with a Camera* (1900); *Camps and Cruises of an Ornithologist* (1908); *My Tropical Air Castle* (1929); 'Who treads our Trails?' (*National Geographic*, Sept. 1937); *Autobiography of a Bird Lover* (1938). Contributor to *Natural History* and other periodicals

Chapman, James, *Travels in the interior of South Africa 1849–1863* (New edition 1971)

Chapman, Wendell and Lucie, *Wilderness Wanderers* (1937); 'With Wild Animals in the Rockies' (*National Geographic*, August 1935); 'Lords of the Rockies: Stalking Big Game with a Color Camera' (*National Geographic*, July 1939)

Chisholm, A. H., *The Romance of the Lyrebird* (1960)

Chislett, Ralph, *Northward-ho!—for Birds* (1933); contributor to *Romance of Nature*

Clark, James L., *Trails of the Hunted* (1929); *Good Hunting* (1966)

Cleaves, Howard H., Photographs reproduced in Aymar, *Bird Flight,* and many other publications

Cook, F. A., *Through the First Antarctic Night* (1900)

Dando, W. P., *Zoo Notes* and photographs of captive animals in *Animal Life and the World of Nature*

David, Ad., *Jagden und Abenteuer in den Gebieten des oberen Nil.* (n.d.)

Delamere, Lord, Photographs reproduced in Lydekker, *Game Animals of Africa* (1908) and other works

Discovery, See R. F. Scott, R. Skelton, A. Saunders

Discovery II, See A. Saunders

Dominis, John, with Maitland Edey: *The Cats of Africa* (1968)

Dugmore, A. Radclyffe, *Bird Homes* (1900); *Camera and Countryside* (—); *Camera Adventures in the African Wilds* (1910); *Wild Life and the Camera* (1912); *The Romance of the Newfoundland Caribou* (1913); *The Romance of the Beaver*

(1914); *Wonderland of Big Game* (1925); *The Vast Sudan* (1926); *In the Heart of the Northern Forests* (1930); *The Autobiography of a Wanderer* (n.d.); Photographs in Stone and Cram, *American Animals* (1902), *Lebensbilder* and many other books and periodicals. Biography: Lowell Thomas, *Rolling Stone* (1933)

Dyott, G. M., *See* J. C. Faunthorpe

Edey, Maitland, with John Dominis: *The Cats of Africa* (1968)

Edgerton, Harold E., 'Humming Birds in Action' (*National Geographic,* August 1947)

Eichorn, Franz, *In der grünen Hölle* (1952)

English, Douglas, Editor of and contributor to *Wild Life*; photographs in *Lebensbilder,* Brehm's *Tierleben,* Step, *Animal Life of the British Isles* (1936)

Farren, Wm, Contributor to *Animal Life and the World of Nature, Wild Life*

Faunthorpe, J. C. 'Jungle Life in India, Burma and Nepal' (*Natural History*, No 2, 1924; photographs by G. M. Dyott)

Ferguson, B. D., Contributor to *Wild Life*

Finley, W. L., with H. T. Bohlman: *American Birds* (1908); *see also* Carl B. Koford, *The California Condor* (1953); photographs reproduced in Aymar, *Bird Flight,* and other works. Contributor to *National Geographic*

Fischer, Hermann, with H. N. Woltereck: *Pirsch ohne Büchse* (1960). Photographs reproduced in many books and periodicals

Fortune, Riley, Contributor to *Wild Life*

Francke, H., *Z-i-i-h- die Beutelmeise* (1938)

Fritsch, G., *Drei Jahre in Südafrika* (—);

Gesner, Conrad, Thierbuch (1563)

Glover, T. A., *See* Angus Buchanan, Stella Court Treatt

Gordon, Seton, *Amid Snowy Wastes* (1922); *Days with the Golden Eagle* (1927); *Thirty Years of Nature Photography* (1936), *Wild Birds in Britain* (1938); *The Golden Eagle, King of Birds* (1955); contributor to *Romance of Nature* and many other publications

Grainer, Fr, Photographs reproduced in Baillie-Grohman, *Sport in the Alps* (1896); Wurm (1897); Bergmiller, *Erfahrungen auf dem Gebiet der hohen Jagd* (1912); Brehm's *Tierleben* (1912)

Griffin, Donald R., 'Mystery Mammals of the Twilight' (*National Geographic*, July 1946)

Gromier, E., *La Vie des Animaux Sauvages de l'Afrique* (1936); *La Faune de la Guinée* (1936); *La Vie des Animaux Sauvages du Cameroun* (1937); *La Vie des Animaux Sauvages de l'Oubangui-Chari* (1938); *La Vie des Animaux Sauvages du Chari Oriental* (1941); *La Vie des Animaux Sauvages du Kénia* (1948); *La Vie des Animaux Sauvages de la Région des Grands Lacs* (1948); *La Vie des Animaux Sauvages du Kilimanjaro* (1948). Contributor to *Le Grand Livre de la Faune Africaine et de sa Chasse* (1954)

Hardy, Eric, 'Early Photographs of Birds' (*Country Life,* May 9, 1952)

Harris, Henry E., *Essays and Photographs; Some Birds of the Canary Islands and South Africa* (1901)

Havilland, Maud D., *A Summer on the Yenesei* (1915); contributor to *Wild Life*

Heck, Ludwig, *See* C. G. Schillings

Hege, Walter, with Egon von Kapherr: *Deutsche Raubvögel* (1933)

Herrick, Francis H., *The Home Life of Wild Birds* (1901); *The American Eagle* (1934); *Wild Birds at Home* (1935). Contributor to *National Geographic*

Hewer, H. R., *British Seals* (1974)

Hewins, Charles A., *See* Francis L. Allen

Heye, Arthur, *Filmjagd auf Kolibri und Faultiere* (1929)

Higham, W. E., *Birds in Camera* (1949). Contributor to *Romance of Nature*

Hoffmann, G., *Rund um den Kranich* (1936)

Holzworth, John M., *The Wild Grizzlies of Alaska* (1930)

Hoogerwerf, A., Udjung Kulon: *The Land of the last Javan Rhinoceros* (1970). Photographs reproduced in many books and periodicals

Hosking, Eric, with C. Newberry: *Intimate Sketches from Bird Life* (1940); *Birds of the Day* (1944); *Birds of the Night* (1945); *More Birds of the Day* (1946); *Birds in Action* (1949); with Frank W. Lane: *An Eye for a Bird* (1970). Contributor to *Romance of Nature*. Photographs reproduced in many books and periodicals

Hubback, T., 'The two-horned Asiatic Rhinoceros'; 'Malayan Gaur or Seladang'; 'Principles of Wildlife Conservation' (all in *Journal of the Bombay Natural History Society,* Vol. XL)

Hubert, E., *La Faune des Grands Mammifères de la Plaine Rwindi-Rutshuru* (1947)

Hurley, Frank, *Argonauts of the South* (1925); *Shackleton's Argonauts* (1948). Photographs in Mawson, *Home of the Blizzard*, and Shackleton, *South*

Ingram, G. C. S., Contributor to *Wild Life*; *Romance of Nature*

Jackson, Frederick G., *A 1000 Days in the Arctic* (1899); 'Arctic Animals' (*Animal Life and the World of Nature*)

Jeary, Bertram, *Pride of Lions* (1936)

Johnson, Martin, *Camera Trails in Africa* (1924); *Safari* (1928); *Lion* (1929); *Congorilla* (1931); *Over African Jungles* (1935). Contributor to *Natural History* and other periodicals. Biography: Osa Johnson, *I married Adventure* (1940)

Johnson, Osa, *Four Years in Paradise* (1941); *Last Adventure: The Martin Johnsons in Borneo* (1967)

Kakies, Martin, *Das Buch vom Elch* (1936; reprint 1954)

Kapherr, Egon von, *Drei Jahre in Sibirien* (1914); with Walter Hege, *Deutsche Raubvögel* (1933). Photographs reproduced in *Lebensbilder*

Kearton, Cherry, *Wild Life across the World* (1913); *Photographing Wild Life across the World* (n.d.); *The Shifting Sands of Algeria* (1924); *In the Land of the Lion* (1929); *The Island of Penguins* (1931); *I visit the Antipodes* (1937); with James Barnes: *Through Central Africa from East to West* (1915). Autobiography: *Adventures with Animals and Men* (1936)

Kearton, John, *Bird Life in England* (1931). Contributor to *Romance of Nature*

Kearton, Richard, in collaboration with Cherry Kearton: *British Birds' Nests* (1895); *Nature and the Camera* (1897); *Our rarer*

British Breeding Birds (1899); *Our Bird Friends* (1900); *Wild Nature's Ways* (1903); *Kearton's Nature Pictures* (1910). Editor and part illustrator of 1903 and 1924 editions of White's *Natural History of Selborne*

Kiesling, M., *See* C. G. Schillings

King, C. J., Contributor to *Wild Life*

Kirk, Charles, *Wild Birds at Home* (5 volumes of Gowan's *Nature Books*). Photographs in *Lebensbilder,* Brehm's *Tierleben*

Kirk, John, *The Zambesi Journal and Letters* (1965, ed. by R. Foskett)

Knight, C. W. R., *Wild Life in Treetops* (1921); *Aristocrats of the Air* (1925); *The Book of the Golden Eagle* (n.d.); *Knight in Africa* (1937). Contributor to *Wild Life, Romance of Nature*

Krieg, Hans, *Als Zoologe in der Steppen und Wäldern Patagoniens* (1940); *Zwischen Anden und Atlantik* (1948). *See also* E. Schuhmacher

Krüdener, Baron von, Photographs published in Wurm (1897)

Lang, Herbert, *South Africa's Big Game and other Animals* (n.d.). Contributor to *Natural History, Animal Kingdom.* Photographs reproduced in many books and periodicals

Leverkus, A., Contributor to *Lebensbilder*

Lieberenz, Paul, *See* H. Schomburgk

Lippens, Léon, *Parmi les Bêtes de la Brousse* (n.d.)

Littlejohn, R. T., *See* A. H. Chisholm

Lockley, R. M., *Shearwaters* (1942); *Puffins* (1953); *The Seal and the Curragh* (1954). Contributor to *Romance of Nature*

Lodge, R. B., *Pictures of Bird Life* (1904); *Bird Hunting through Wild Europe* (1908). Contributor to *Animal Life and the World of Nature, Wild Life*

Loring, J. Alden, *African Adventure Stories* (1914)

Lowther, E. H. N., *A Bird Photographer in India* (1949); with R. S. P. Bates: *Breeding Birds of Kashmir* (1952)

Macpherson, H. B., *The Home Life of the Golden Eagle* (1911). Contributor to *Wild Life*

Madsen, Johannes, Contributor to *Animal Life and the World of Nature*

Markham, J., Contributor to *Romance of Nature*

Marples, George and Anne, *Sea Terns or Sea Swallows* (1934)

Mawson, Sir Douglas, *The Home of the Blizzard* (1915; many photographs by Frank Hurley)

Maxwell, Marcuswell, *Big Game Photographs* (n.d.); *Elephants and other Big Game Studies* (1930). Photographs reproduced in many books and periodicals

Maxwell, Marius, *Stalking Big Game with a Camera in Equatorial Africa* (1925)

Meerwarth, H., *Photographische Naturstudien* (1905. German edition of A. R. Dugmore's *Camera and Countryside*). Editor of and contributor to *Lebensbilder aus der Tierwelt*

Mittelholzer, W., *Kilimandjaro Flug* (1930)

Murphy, R. C., *Bird Islands of Peru* (1925)

Musselwhite, Arthur, *Behind the Lens in Tigerland* (1933)

Muybridge, Eadweard James, *Animal Locomotion* (1887)

Nansen, Fridtjof, *Farthest North* (1903); photographs reproduced in *Lebensbilder*

Newbold, C., *See Challenger* Expedition
Noll, Hans, *Sumpfvogelleben* (1924)
Norris, Hill, *See* John Kirk
Notman, William, *See* H. G. Vennor
Oertzen, Jasper von, *In Wildnis und Gefangenschaft* (1913)
Olson, Oskar, *See* William, Prince of Sweden
Paasche, Hans, *Im Morgenlicht* (1907)
Peacock, E. H., *A Game-Book for Burma and adjoining Territories* (1933)
Percy, Lord William, *Three Studies in Bird Character* (1951). Contributor to *Romance of Nature*
Pike, Oliver G., *Hillside, Rock and Dale: Bird Life, Pictures with Pen and Camera* (—); *In Bird-Land with Field Glass and Camera* (—); *Home Life in Bird-Land* (1906); *The Nightingale, its Story and Song* (1933); *Wild Animals in Britain* (1950); 'Early Photographs of Bird Life' (*The Photographic Journal*, Section A, July 1951). An Historic Series of Cuckoo Photographs (*British Birds*, Vol. LII). Contributor to *Animal Life and the World of Nature, Wild Life, Romance of Nature* and many other periodicals. Photographs reproduced in Chance, *Truth about the Cuckoo* (1940)
Pitt, Frances, *British Animal Life* (—); *Wild Animals in Britain* (1938); *Birds in Britain* (1938). Contributor to *Wild Life*. Editor of and contributor to *Romance of Nature*. Autobiography: *Country Years* (1961)
Ponting, Herbert G., *The Great White South* (1921; many editions). Photographs in *Scott's Last Expedition* and in many other books and periodicals. Biography: H. J. Arnold, *Photographer of the World* (1969)
Ratibor, Duke of, Photographs in Wurm (1897)
Roosevelt, Theodore, *African Game Trails* (1910; photographs mainly by Kermit Roosevelt)
Rosen, Count Eric von, Photographs in *Lebensbilder*
Salmon, H. Morrey, Contributor to *Wild Life, Romance of Nature*
Sanden, Walter von, *Guja, See der Vögel* (1933); *Am See der Zwergrohrdommel* (n.d.)
Saunders, A., *A Camera in the Antarctic* (n.d.)
Schack, W., with Otto Leege and H. Focke: *Wunder des Mövenfluges* (1937); *Ich jagte das Weisse Nashorn* (1958)
Schaefer, E., *Berg, Buddhas und Bären* (1933); *Unbekanntes Tibet* (1937); *Dach der Welt* (1938); 'Ornithologische Ergebnisse zweier Forschungsreisen nach Tibet' (*Journal für Ornithologie*, 1938); *Ueber den Himalaya ins Land der Götter* (1950)
Schillings, C. G., *Mit Blitzlicht und Büchse* (1905); *Im Zauber des Elelescho* (1906). (English translations: *With Flashlight and Rifle*; *In Wildest Africa*)
Schocher, B., *Herrliche Alpentiere* (1939); *Murmeli: Erlebnisse mit Alpenmurmeltieren* (1946)
Schomburgk, Hans, *Wild und Wilde im Herzen Afrikas* (1910); *Bwakukama: Fahrten und Forschungen mit Büchse und Film im unbekannten Afrika* (1928); *Zelte in Afrika* (1931); *Das letzte Paradies: Eine Filmfahrt nach Afrika* (n.d.)
Schuhmacher, Eugen, *Unter Säbelschnäblern und Seeschwalben* (1937); *Meine Filmtiere* (1951); *Der Berg lebt* (1958); *Ich*

filmte tausend Tiere (1970). Photographs reproduced in Krieg (1940, 1948)

Schulz, Christoph, *Auf Grosstierfang für Hagenbeck* (1926)

Schumann, Robert, *See* Christoph Schulz

Scotia Expedition, R. N. Rudmose Brown, R. C. Mossman, J. H. Harvey Pirie: *The Voyage of the Scotia* (1906); '*Life in the Antarctic,* by Members of the Scottish National Antarctic Expedition' (*Gowan's Nature Book,* No. 10, 1907); 'Report on the Scientific Results of the Voyage of S.Y. Scotia': *Zoological Log* (Vol. IV, Part I, 1908)

Scott, R. F., *The Voyage of the Discovery* (1907; photographs mainly by R. Skelton); *Scott's last Expedition* (1913; many photographs by Herbert G. Ponting)

Shackelford, J. B., Photographs reproduced in Andrews (1924, 1926)

Shackleton, Sir Ernest, *South* (1920; photographs by Frank Hurley)

Shiras, George, *Hunting Wild Life with Camera and Flashlight* (1935). Contributor to *National Geographic*

Siewert, Horst, *Störche: Erlebnisse mit dem Schwarzen und Weissen Storch* (1932)

Skelton, R., Photographs in R. F. Scott, *The Voyage of the Discovery* (1907) and E. A. Wilson, *Zoology of the National Antarctic Expedition . . .* (1907)

Snell, F. C., *A Camera in the Fields: A practical Guide to Nature Photography* (1905)

Soffel, Karl, Zoological Editor of and contributor to *Lebensbilder aus der Tierwelt*

Someren, V. G. L. van, *Days with Birds: Studies of Habits of some East African Species* (1956); with R. A. L. van Someren: *Studies of Bird Life in Uganda* (1911); photographs in Praed and Grant, *Birds of Eastern and Northeastern Africa*

Steckel, Max, *Kamera Weidwerk* (1927); photographs in *Lebensbilder*

Stockley, C. H., *Stalking in the Himalayas and northern India* (1936)

Symonds, J. S., Contributor to *Wild Life, Romance of Nature*

Taylor, Arthur, Contributor to *Wild Life, Romance of Nature*

Thomson, Ian M., *Birds from the Hide* (1933). Contributor to *Romance of Nature*

Treatt, C. Court, *Out of the Beaten Track; a narrative of Travel in little known Africa* (n.d.)

Treatt, Stella Court, *Cape to Cairo* (1927); photographs by T. A. Glover; *Sudan Sand* (1930)

Turner, E. L., *Broadland Birds* (1924); contributor to *Wild Life, Romance of Nature*

Tyrrell, J. B., Photographs reproduced in Hewitt, *The Conservation of Wild Life in Canada* (1921)

Udet, Ernst, *Fremde Vögel über Afrika* (1932)

Vennor, H. G., *Our Birds of Prey, or the Eagles, Hawks and Owls of Canada* (1876; illustrated with mounted photographs of stuffed birds taken by W. Notman)

Walker, Ernest P., 'Flying Squirrels, Nature's Gliders' (*National Geographic,* May 1947)

Wallihan, A. G., with Mrs Wallihan: *Camera Shots at Big Game* (1901)

Watteville, Vivienne de, *Out in the Blue* (1927); *Speak to the Earth* (1935)

Wesslén, Stig, *Im Tal der Königsadler*; *In Fischadlers Reich* (n.d.)

William, Prince of Sweden, *Among Pygmies and Gorillas* (1923); *Wild African Animals I have known* (1923; photographs by Oskar Olson)

Wilson, Edward A., *Zoology of the National Antarctic Expedition 1901–1904: Mammalia and Aves* (1907). Photographs by Skelton, paintings and drawings by Wilson.

Wurm, W., *Jagdtiere Mittel – Europas* (1897)

Wyles, Benjamin, 'The Camera amongst the Sea Birds' (*Strand Magazine,* Vol. 4, 1892)

Yeates, G. K., *The Life of the Rook* (1934); *Bird Life in two Deltas* (1946); *Bird Haunts in Northern England* (1947); *Bird Haunts in Southern England* (1948); *Flamingo City* (1950); *The Land of the Loon* (1951). Contributor to *Romance of Nature*

Zedtwitz, Count Franz, *Vogelkinder der Waikariffe* (1933); *Gams in ihrer Bergheimat* (1939)

Index

Page numbers in italic refer to illustrations